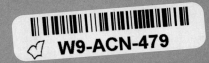

FRAGILE DWELLING

MARGARET MORTON

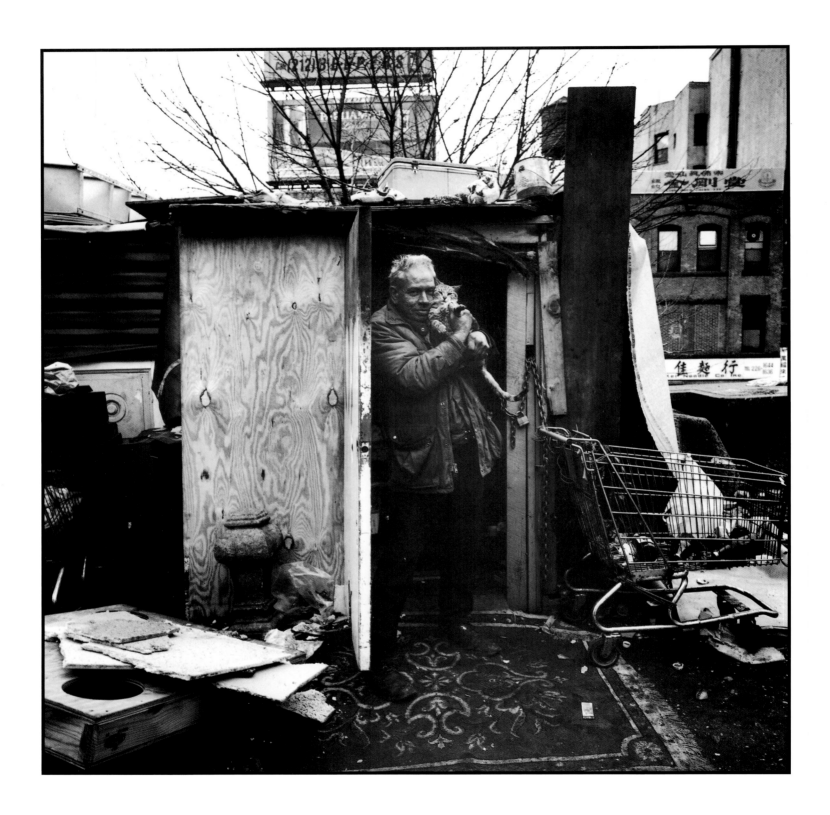

Louie with kitten, the Hill, 1992

FRAGILE DWELLING

MARGARET MORTON

Introduction by Alan Trachtenberg

APERTURE

This book is dedicated to the women and men who graciously invited me into their homes and shared their stories.

Introduction

by Alan Trachtenberg

For ten years, Margaret Morton has journeyed with her camera into spaces of New York City little imagined, let alone frequented, by most of its residents. With a combination of determined curiosity and tactfulness, she has visited these occluded spaces and made them visible in remarkable pictures of human survival. One wonders how she achieved this feat, how she managed to break through the protective wall with which city dwellers remove themselves from unwanted scenes of wretchedness and disarray. Moreover, this achievement goes beyond the shattering of a wall or the rending of a veil. Morton shows us something beyond a culture of despair, something to wonder at, to admire, even to celebrate, in an act of courage parallel to the courage she perceives.

In 1989, Morton observed a settlement of improvised shacks and tents that had mushroomed near her home, a community of "fragile dwellings" pieced together out of every imaginable shred of material at hand for scavengers of the city's bourgeois debris. Here was a kind of vernacular architecture that instantly caught her photographic eye: living examples of bricolage shaped by the most urgent of human needs for shelter, warmth, community, the pleasure of making a place of one's own and calling it home. It's no surprise that the shelters erected without license in a public park were doomed to fall beneath police clubs and city bulldozers, doomed as a public nuisance. Witnessing those makeshift structures so pitilessly scooped into a dumpster marked the onset of her explorations of the underside of the city's multifarious life.

Drawn at first to the imaginative forms of the temporary housing erected throughout the city out of simple need, Morton found herself drawn to the people themselves, the city's most abused and allegedly helpless underclass. Recording their stories on tape, she came to define her project as something more than the making of photographs. She became an investigator, probing dark, often dangerous places for disclosures of hidden truths. But there is a great difference between Morton's investigations and those of Jacob Riis and other

nineteenth-century charitable reformers, who viewed the inhabitants of slums with distaste and some disdain. Without a hint of condescension, Morton gives us images that tell stories of survival in the face of unimaginable odds. These stories tell of persistence and creativity: dwellings get put together, gardens designed and planted, laundry hung out to dry, breakfast and dinner laid out on whatever makes do as a table. It's a precarious existence of the sort impossible to comprehend without having witnessed it firsthand. And firsthand is clearly what these photographs are.

Morton's pictures invert the pathos and aversion usually attached to the word *homeless*. Not that they flinch from the facts of abject poverty. But the "culture of poverty" in the usual sense of the term is not quite the issue here. It's not simply the result of unemployment or hard luck we see, but something even more affecting: abandonment, reclusiveness, the outcast condition. Perhaps most striking about the photographs is the way they communicate the effects of recognition that the camera itself produces. We see people see themselves *seen*, acknowledged and respected. Morton invites her subjects to participate in her pictures of them, to arrange themselves and their surroundings as *they* want to be perceived. And she shows the places they create as environments nested within and pressing against the larger environment of the city, with all its emblems of indifference and abstract power. She allows her subjects the dignity of presenting themselves as artists in their own right, creators of a domestic architecture which, though it may emerge from despair, gives testimony to the possibility of joy and pride even in conditions of utmost deprivation. Look at the images and icons pinned on shabby walls, the touches of elegance in scale and shape. Fragility itself becomes a whole way of life, certainly not idealized, but taken for what it is: making the best of it with what's at hand. And she allows us to see and feel their world as if from the inside.

No small feat, this transposition of subject and viewer. And the montage effect of images and voices comprise a phenomenology of living art among the most marginalized of our population. It's with a shock of recognition that we see these people as pioneers of a sort, camping out on the frontier of bottom-rung urban existence. The bleakest of settings become, in Morton's pictures, sites of a kind of "improvement" that comments trenchantly on the

shameless claim of real estate values, the "market" that has ruled these lost but undefeated souls out of bounds, beyond the pale of normal existence.

Fragile Dwelling crystallizes the paradox at the root of Morton's work: not only the coexistence of wealth and poverty in the world's richest metropolis, but the coexistence of despair and hope in the devices whereby the rejected contrive a life for themselves. We have the paradox of fragility itself: the dangers of hanging on by your fingernails, and the pride of creative survival. We see the hardship, the desperation, but also the will to live. Strangely uplifting and affirming, the pictures give a different look to the solidly planted structures towering with disdain above the "fragile dwellings," the improvised and impermanent homeplaces of the "homeless." The pictures compel us to confront not only their despair of homelessness, but our despair at having these encampments in our midst without comprehending what they mean to the assurances of "normal" life. What truths about our common life are we likely to recognize in Morton's pictures? How do they impinge on our "normalcy"? Can we ever imagine ourselves occupying those spaces, dwelling in those structures, living such vulnerable lives?

Pictures and texts work so well together here that they seem one, emanating from and reflecting each other, urging the reader deeper into the imagination of an underground society brutally shoved to the margins of our awareness. *Fragile Dwelling* also brings home an unrelenting moral predicament. The predicament of the sympathetic viewer is made more severe by the fact that Margaret Morton's pictures neither stereotype nor sentimentalize, idealize or pity. Like their subjects, they take the world as it is. It's an old dilemma we face here: art or reform, beauty or anger, pleasure or discontent. Nightmares of an underground have haunted modern society since the onset of industrialism. *Fragile Dwelling* presents a familiar ordeal of modernity: shocking inequalities, exclusions, abjection. But no one looking at these pictures with any degree of empathy can fail to be moved by the thought that we have among us, while socially invisible for the most part, creative and worthy persons capable of fashioning a kind of beauty. In their tactfulness, the pictures do not judge; whatever judgments we derive from them become our own, and therefore our society's, responsibility.

Prologue

In 1989, when this project began, there were more homeless people in New York City than at any time since the Great Depression. The economic, political, and social shifts that precipitated this massive dislocation are complex, but a convergence of events from the previous decade undoubtedly accelerated the crisis.

The 1970s marked the onset of a dramatic reduction in manufacturing jobs, particularly in New York City. Many low-skill jobs disappeared, casualties of automated production and the use of cheap labor abroad. Soaring unemployment coincided with a sudden decline in the real estate market. In the wake of the city's 1975 fiscal crisis, stringent revisions to property tax laws were instituted. But the city's plan to increase revenues had an unexpected effect: a significant number of landlords, particularly in the South Bronx and on the Lower East Side, responded with arson or abandonment, leaving some five hundred vacant properties in neighborhoods where low-rent housing was desperately needed. Moreover, throughout the past two decades, tens of thousands of chronically ill patients had been discharged from state mental institutions, many without provision for housing or community-based treatment. People wandering the streets and sleeping in public places soon became visible beyond the confines of the Bowery.

By the end of the 1970s, the real estate market began to recover. Rapid gentrification in the city's low-income neighborhoods further reduced the number of affordable apartments and single-room-occupancy (SRO) hotels, inflating the housing market. While the economic expansion that continued through the 1980s brought a surge of wealth to the elite of New York, the outlook for the poor became more dismal. Rules governing eligibility for welfare were tightened, above all for single adult men. Those who succeeded in navigating the tangled bureaucracy received public assistance checks that were inadequate in the face of escalating apartment rents.

A landmark lawsuit filed against the city in 1981, which was settled as the Callahan *consent decree, guaranteed single homeless men the right to shelter. Subsequent litigation*

extended this right to women and families with children. In 1989 alone, some twenty-five thousand homeless poor sought beds in city shelters each night. Converted armories, such as Fort Washington in Upper Manhattan and the Atlantic Avenue Armory in Brooklyn, slept as many as 1,200 men, billeted on floors once used for military drills. These crowded and dangerous conditions led thousands more to sleep outside: huddled in plastic bags or discarded refrigerator boxes, seeking protection in empty doorways, or finding warmth on top of steam grates.

As the situation worsened, a startling phenomenon occurred: homeless people began to improvise housing for themselves. Shantytowns soon became visible in Lower East Side vacant lots, barren since the mid-1970s when landlords had their own buildings torched to collect insurance money. These encampments, unseen on such a scale since the Hoovervilles of the 1930s, also appeared in public parks, under bridges and highway exit ramps, along the rivers, and beneath the streets in subway and railroad tunnels. The largest of these was in Tompkins Square Park in the East Village, where more than two hundred homeless men and women had set up makeshift tents by 1988. On August 6 of that year, a police attempt to impose a midnight curfew erupted into a bloody clash with park residents, visitors, and onlookers. After the homeless people returned, they were swept from the park by police twice more, in July and December 1989. Each time, they made their way back. Then, on June 3, 1991, ignoring a recommendation from the community board, a phalanx of police in riot gear routed the homeless community from the park and closed it for renovation. When the park reopened in August 1992, a curfew was imposed.

Over the next six years, homeless New Yorkers continued to be pushed out of their fragile, self-made dwellings by political pressures, police, and bulldozers. Some of these temporary encampments were demolished after only a few weeks. Others survived for several years and gradually evolved into more permanent settlements.

Bushville

On East Fourth Street, the building facades deteriorate with each step that takes me toward Avenue D: a cracked pane of glass, a twisted iron rail, then a dangling cornice. Next, crumbling stairs rise to a dead end, an arched entrance sealed with cement. Up above, pigeons enter freely through dark, gutted windows.

A few steps later, a large open space interrupts the unrelenting decay, a burst of salsa music reaches the street. On the right, a path leads to a cluster of pale-blue and yellow casitas with wooden porches, gabled roofs, rock gardens, and statues of the Virgin Mary and Saint Francis. String beans and squash vines climb a fence made from orange-plastic bread trays. Rabbits and chickens poke through scraps of a noonday meal.

The residents of Bushville came to New York from the villages of Puerto Rico. They arrived as young men with dreams of a better life. Soon they discovered low pay, illness, and bad luck. Thirty years later, the men were unemployed and homeless, but not without the will to survive. They cleared debris from this deserted lot, scavenged building material in the early morning hours, and constructed plywood houses along a central path.

The men continually embellish their homes with additions that stir memories of the place they left behind: an interior courtyard, a covered walkway, an inflated plastic palm tree, a Puerto Rican flag.

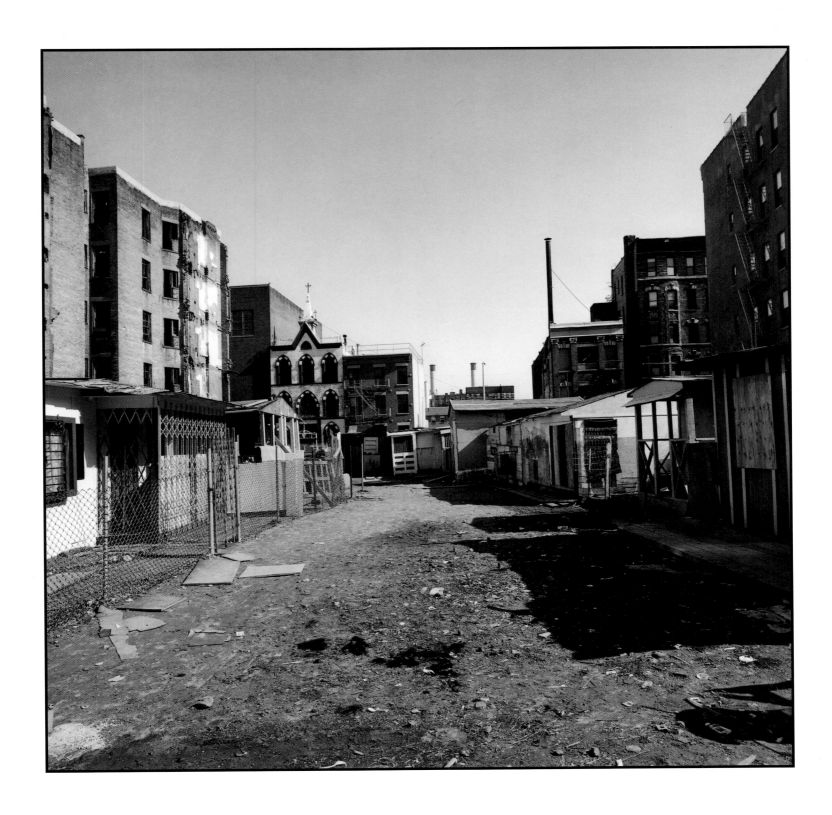

Bushville, Lower East Side, 1993

Pepe

Otero *means "watchman." That's what I am. I watch out for everybody here. But nobody watches out for me.*

I was born in the countryside. In the seventh grade, I started bookbinding in a little print shop. Then I learned typesetting and printing and started making sixty dollars a week. I was sixteen years old. From there I went to San Juan. I came to this country when I was nineteen, because somebody told me I could make a lot of money in New Jersey, in typesetting. I said, "Oh yeah? Then I'll go to New York." When I came to New York I got a big, bad surprise, because in those times the minimum salary was thirty-four dollars a week. I was making more money in Puerto Rico.

Because I was fast in [manual] typesetting, I became a machine operator. Then I made sixty-four dollars a week. From there I went into electronics: making lamps, fixing lamps, making custom bases, buffing. In 1957 I had a bad accident on the buffing machine. I almost lost a hand. That's a nightmare to me. Then I was working for a friend of mine, but he started getting nasty. I quit for good six months ago. I'm an old man. I'm going to collect my old man check. The check is not enough to pay the rent. That's why I'm here.

Pepe, Bushville, 1991

I was living in a room at First Street and First Avenue. The rent was too high, seventy dollars a week. The bathroom was outside. I had to wash the sink before I used it. It stunk. They peed all over the seat. You could barely walk into the place—there was a line on the stairs to buy drugs. Every day it was raining there. Once the place was on fire. It wore me out. The city don't want to fix it up, so I don't pay rent. I don't pay rent, I had to go. I was in Tompkins Square Park for six months. I made my tent with plastic bags. It was up to me to keep my surroundings clean.

I've been here since 1990. When I took over, there was nothing, only this room. A friend of mine started this house, that's why it's so low. I had to push it up two inches more. I put in a new beam, this one in the center. It had so many leaks, leaking all over. I did the rest of the house. I added the awning. I've improved it, and I'm going to improve it some more—try to make it better for next winter.

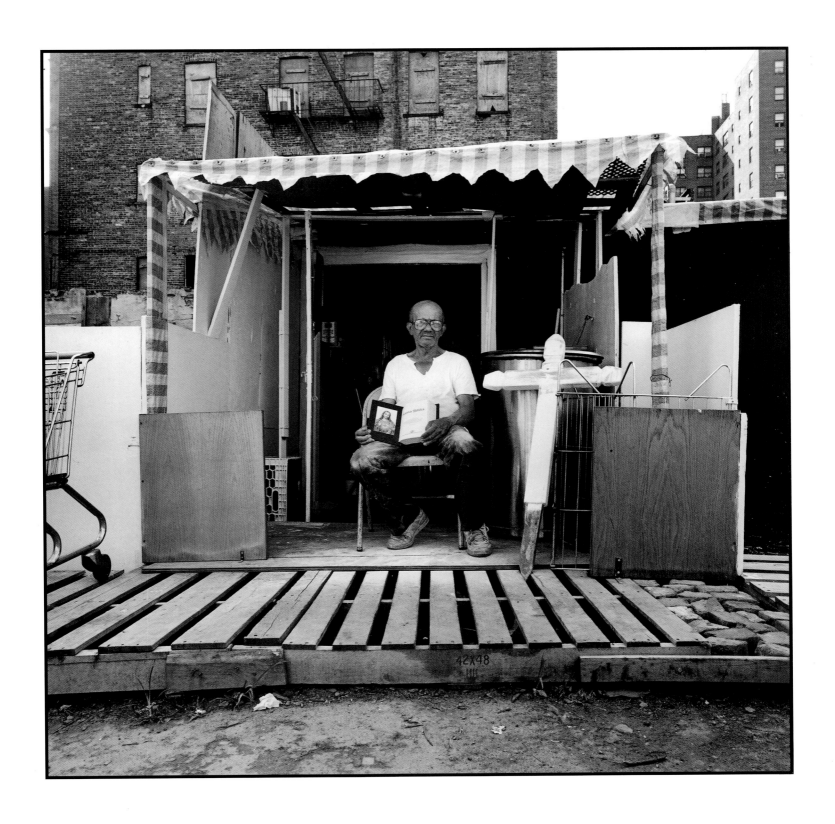

Pepe, Bushville, 1991

Pepe's toolroom, Bushville, 1993

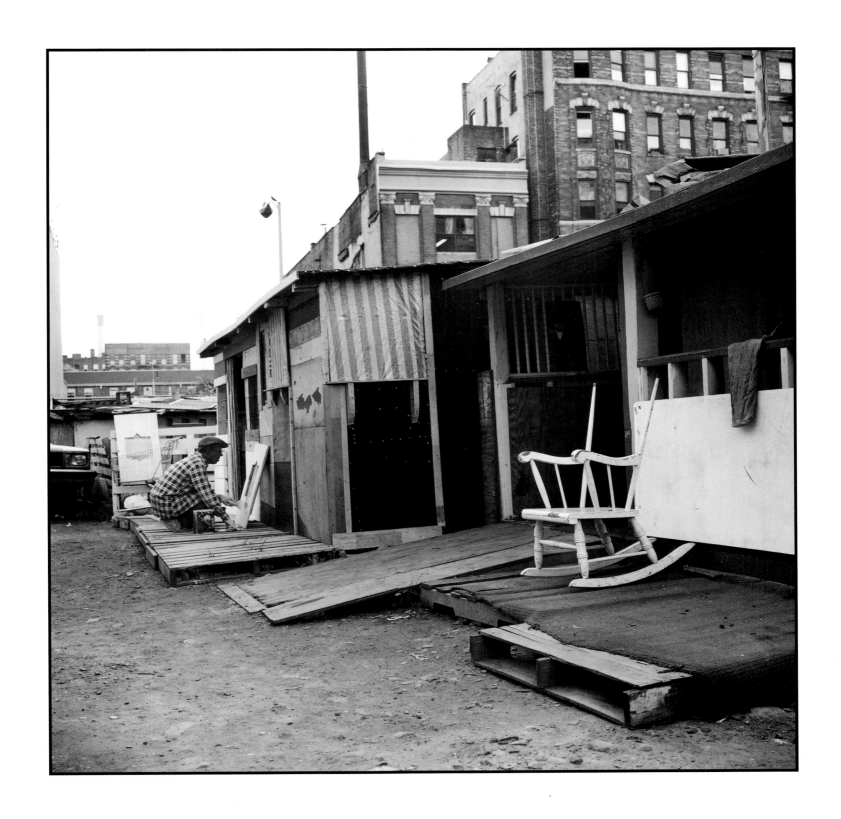

Pepe, Bushville, 1991

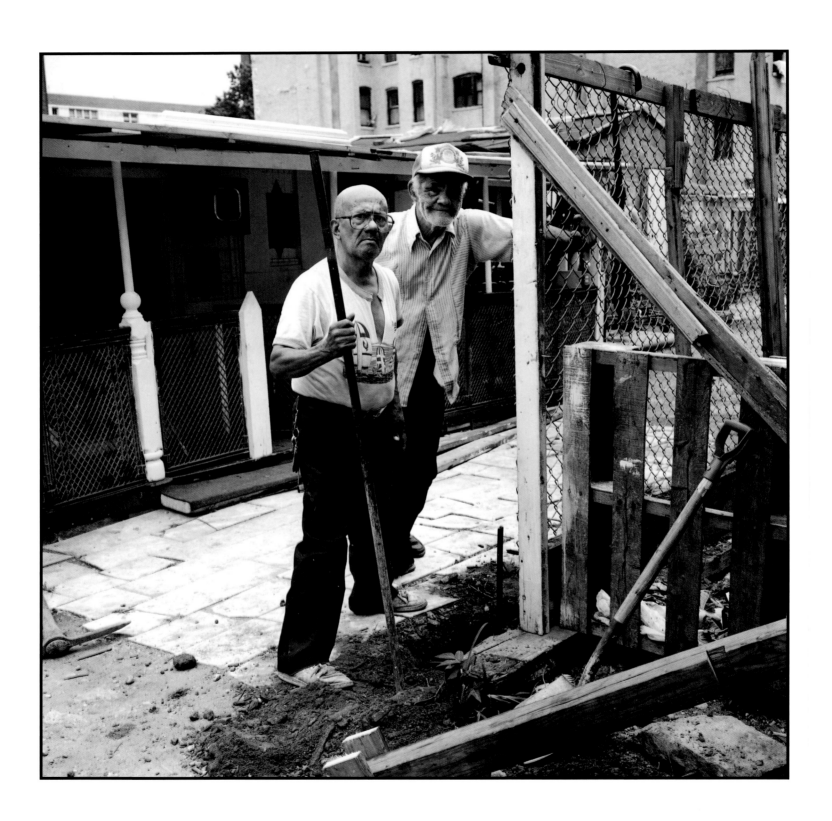

Pepe and his visitor, Papito, Bushville, 1992

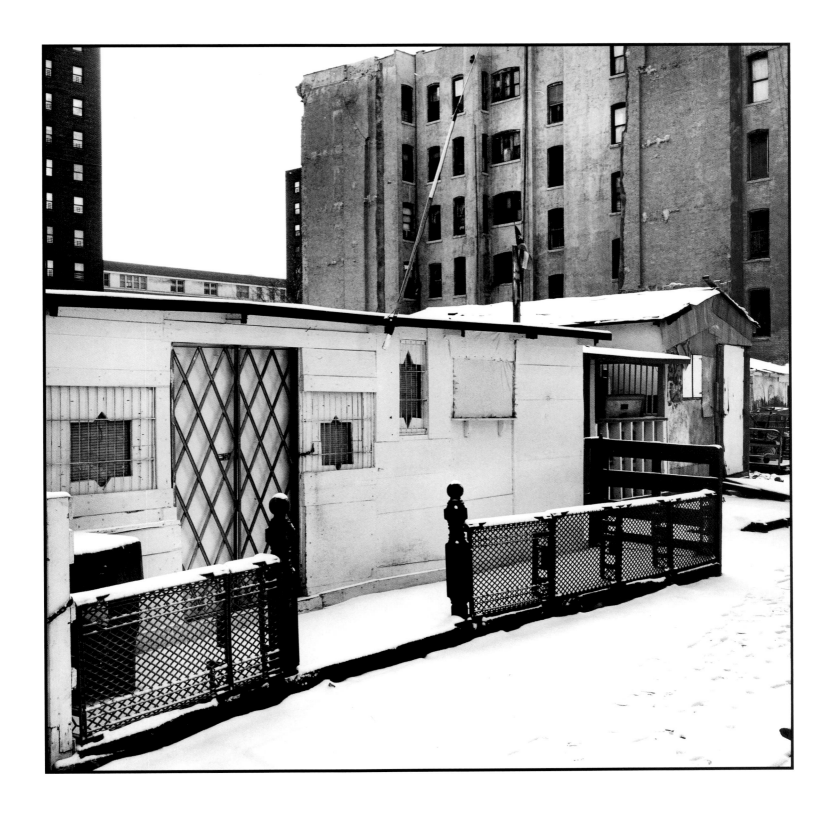

Pepe's house, 1992

Pepe

I'm no architect. God is the architect—He is the best architect in town. I have plenty of time. I have to live someplace, it's all I have.

Some [building material] I buy, some I find at construction sites. Then there are people who...."Want to buy these?" One time a guy came in with brand-new plywood from a theater, giving it away. I bought good wood from another guy, but I didn't get to use it. Somebody stole it from me. The ceiling is plywood sealed with linoleum. I took wood, covered the inside walls, took some insulation. I've got a kerosene heater inside and a wood stove outside.

I'm going to make the porch look better. In Puerto Rico we have things like that. I've got some red plastic, I'm going to make it [whistles] in the summertime, to sit outside. I'd like to get some fifteen-inch speakers. I got no habit. I don't drink, I don't smoke, I don't do drugs. I make noise. I'm hooked on music, that's all. I stopped drinking for good about three or four months ago.

[The toolroom] is still unfinished, too cold now. I'd like to finish the kitchen. Then I'm going to start the bathroom, soon as the weather get a little warmer—if I still alive.

My house in Puerto Rico, it was beautiful, a big house with a balcony. And so many rooms.

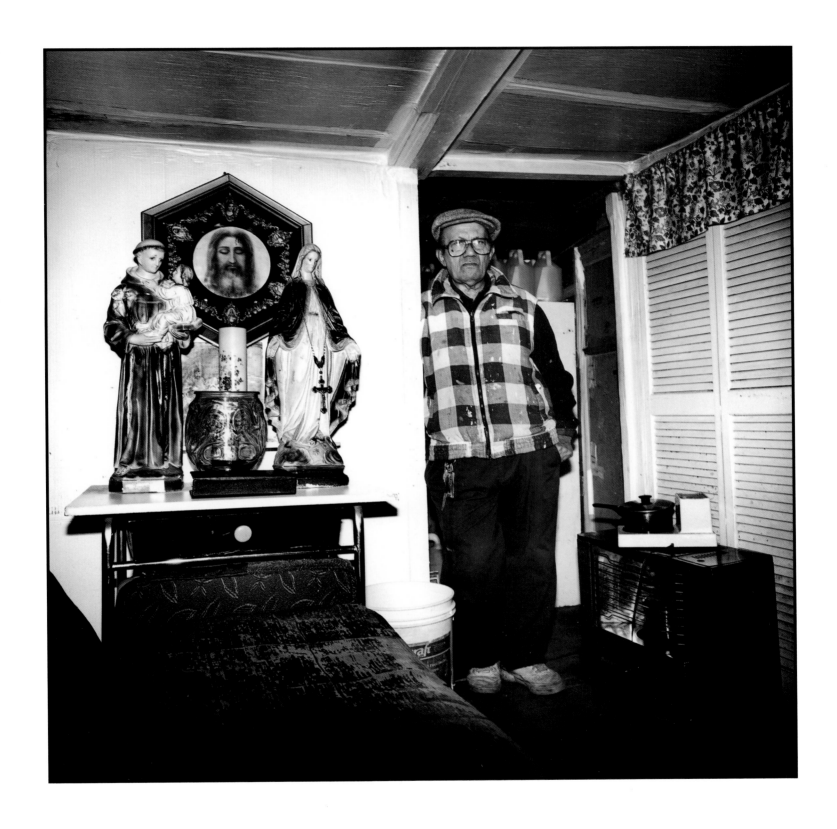

Pepe, Bushville, 1993

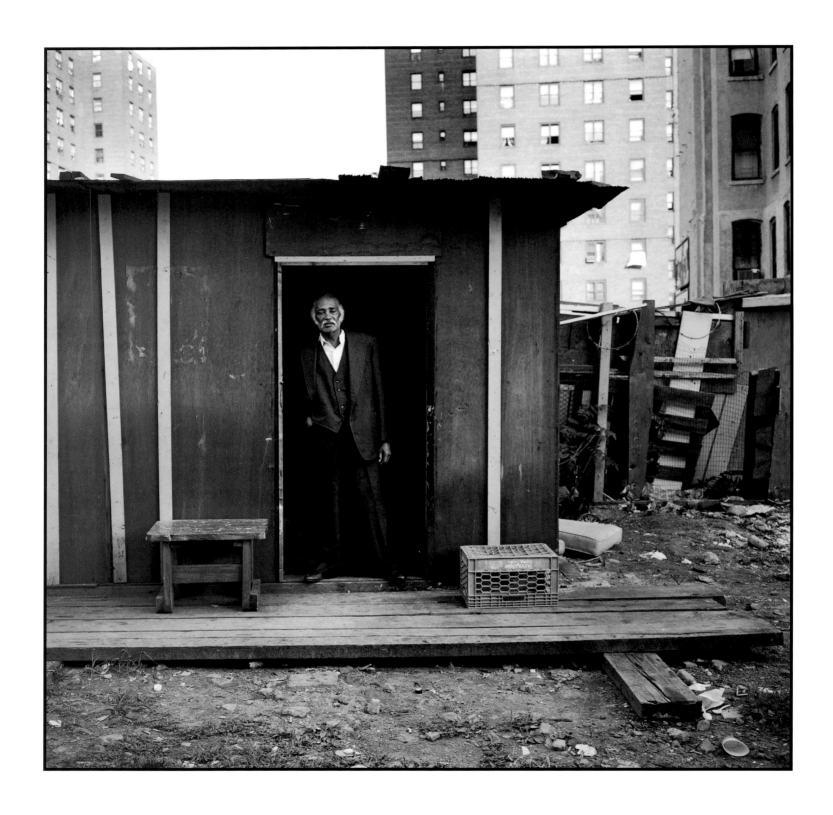

Mario, Bushville, 1993

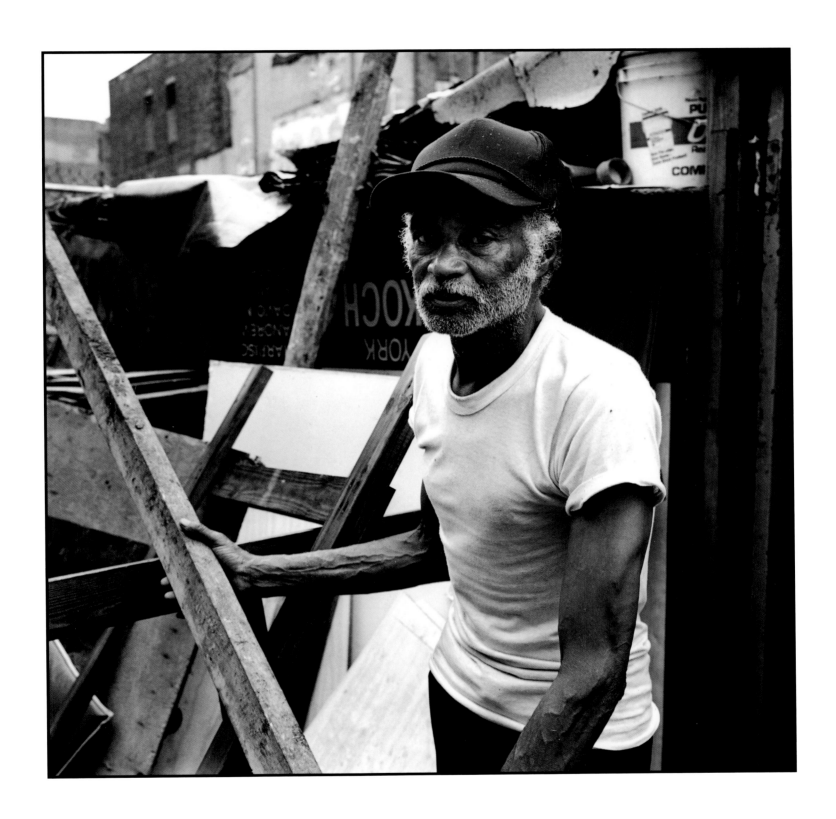

Mario, Bushville, 1992

23

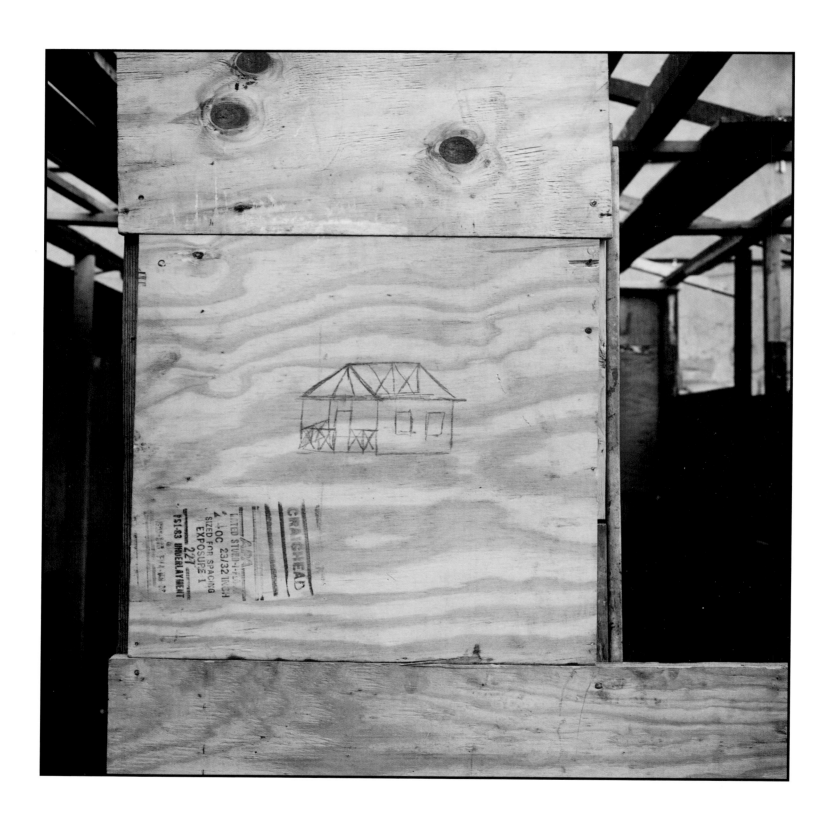

Sketch for Hector's house, Bushville, 1991

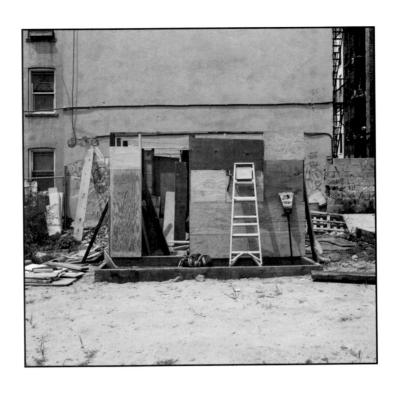

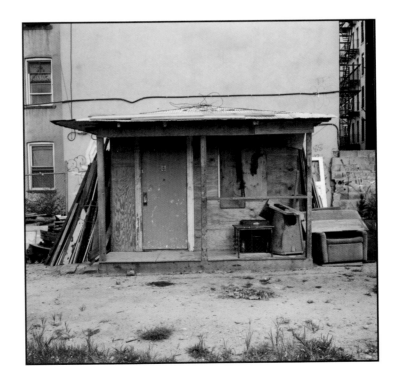

Hector's house, Bushville, 1991

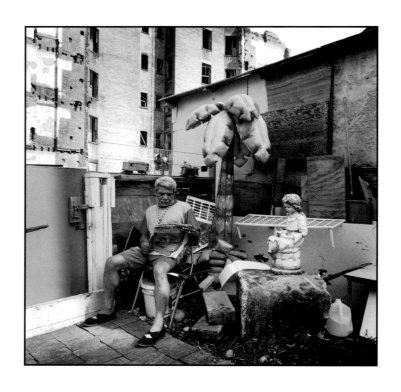

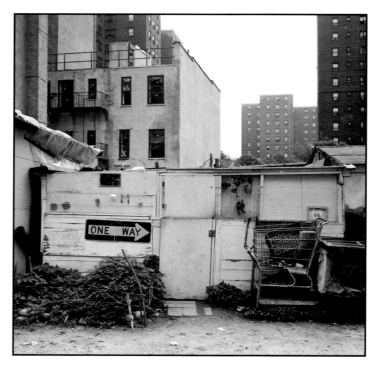

Hector A, Bushville, 1991; Hector A's house, Bushville, 1992

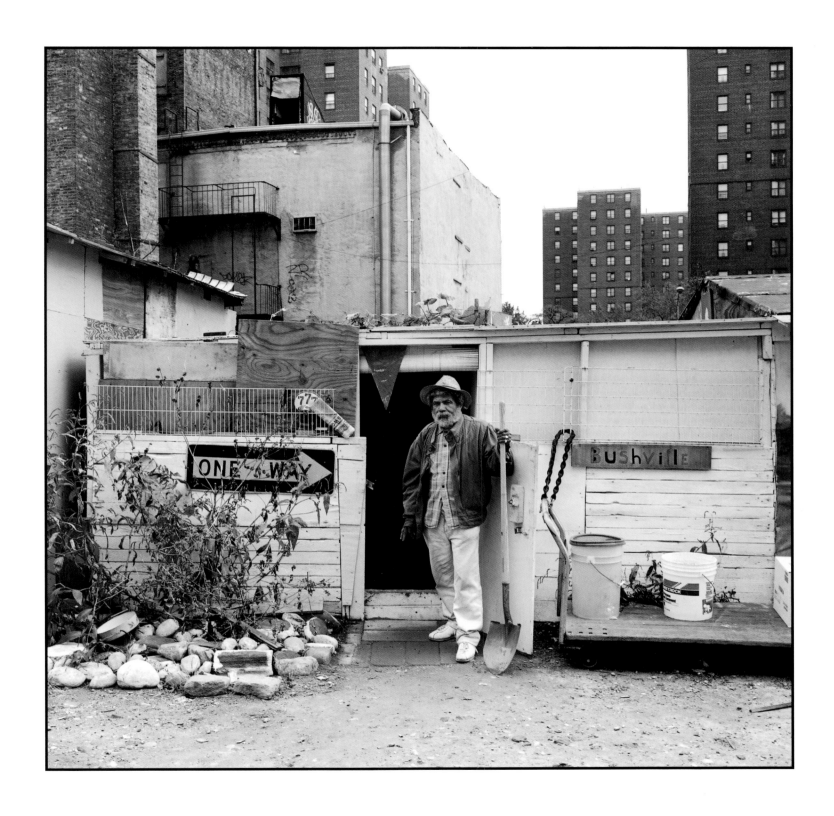

Hector A, Bushville, 1991

Hector A

Bushville, that's the name. I put [the salvaged sign] up myself, about one year ago.
Now they have to start working, making the place look nice, clean, and paint the houses
—like a little town. If people don't respect me, they have to respect the name.

The first time that I moved here was more than two years ago. Before me, this place was
garbage. There were only two houses—all this was empty land. I built this house myself.
Everything, I carry it, from the street, from everywhere—Eighth Avenue, First Avenue.
Everything I found in my way, I take it, little by little, little by everything. I bring these
blocks from Avenue B. I carry maybe fifty. They finish a building, they don't want, they
don't need—I want. I start one o'clock in the morning and finish four o'clock. When you
want something, no matter if it weighs two hundred pounds or three hundred, you can
carry, because God helps you. With God you can carry everything.

When I came here, I start like a poor person. Now I feel better. I feel comfortable.
I figure this is my breakthrough to stay here. If I don't do something here, my mind will
die. I'm an old man already. I'm on to fifty-five. Too much for me. For me it's like
a hundred.

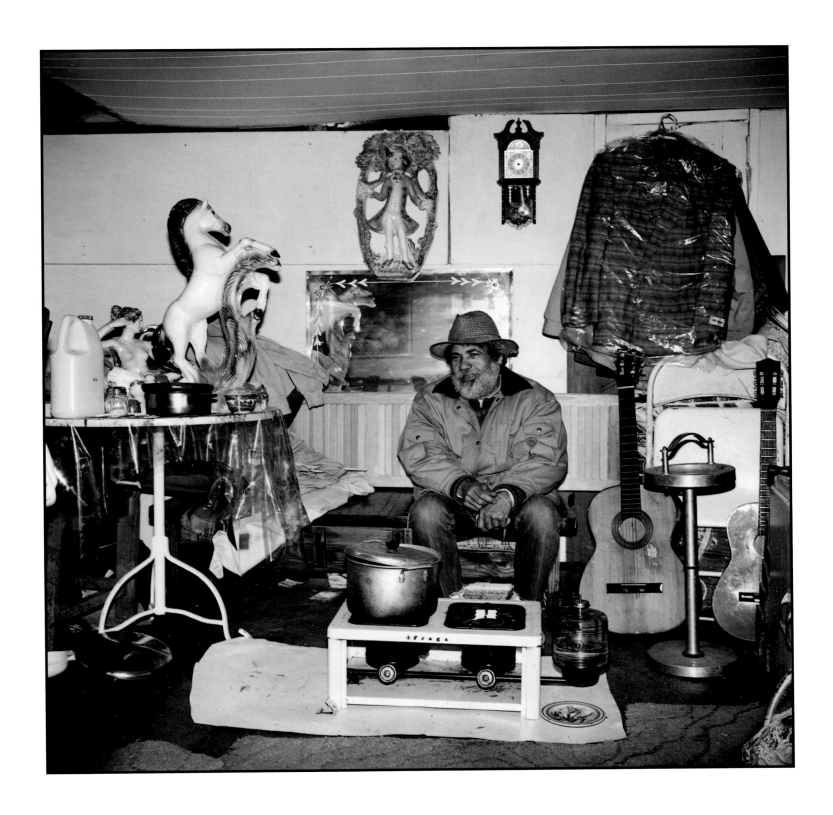

Hector A, Bushville, 1991

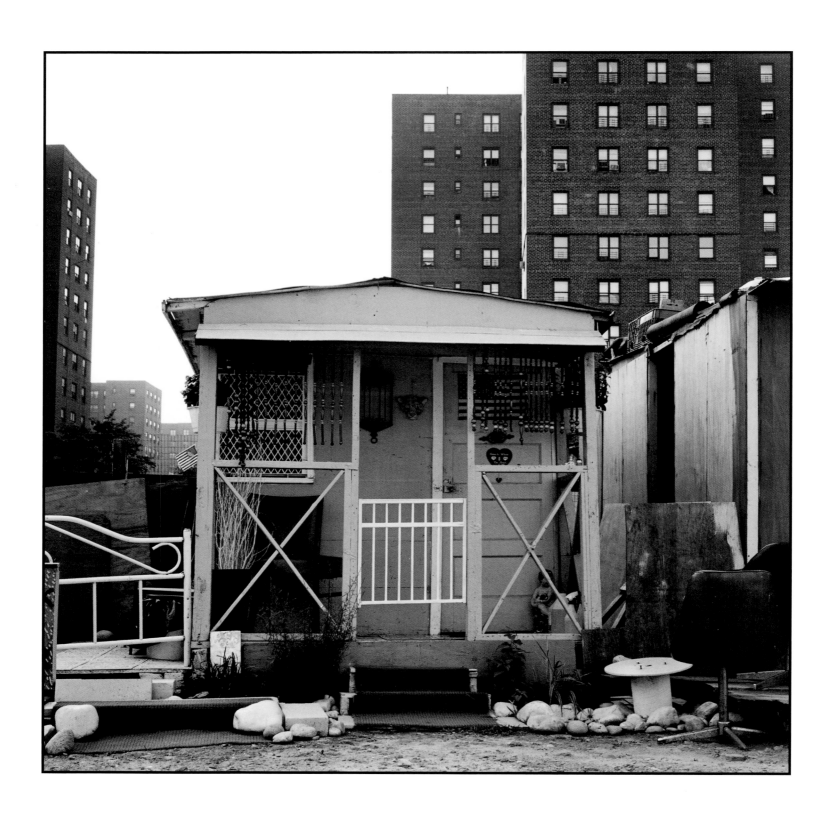

Yvette and Monin's house, Bushville, 1991

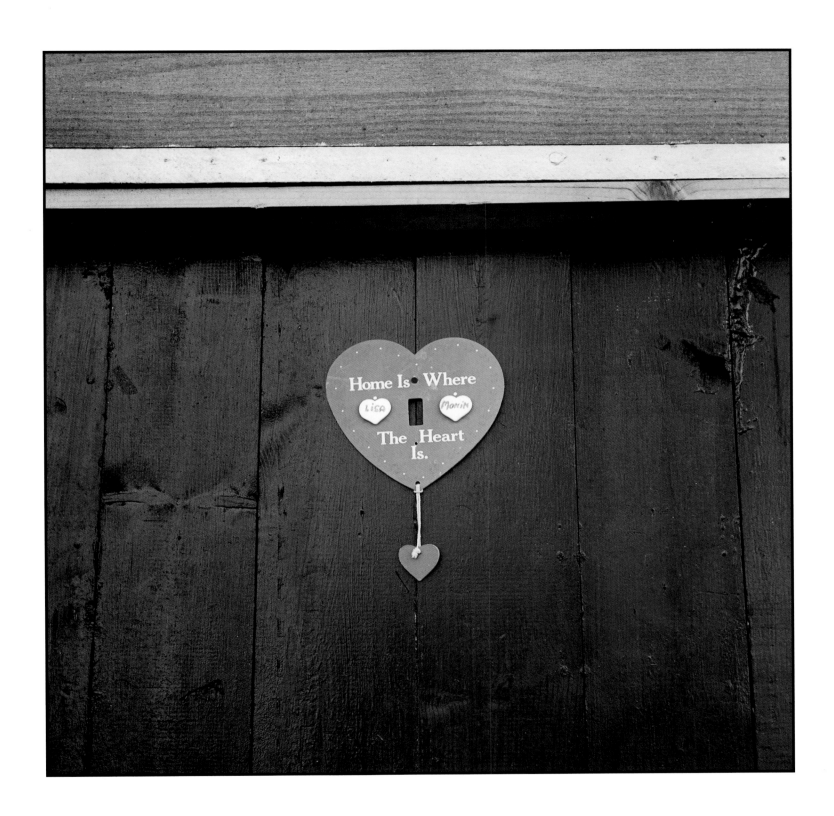

Sign on Yvette and Monin's house, Bushville, 1991

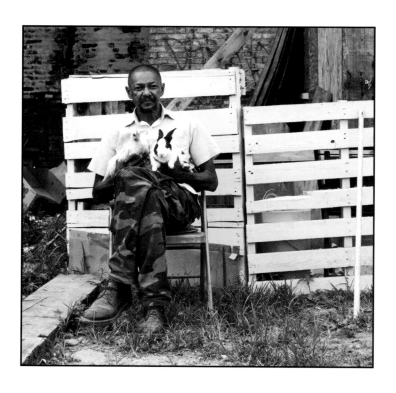

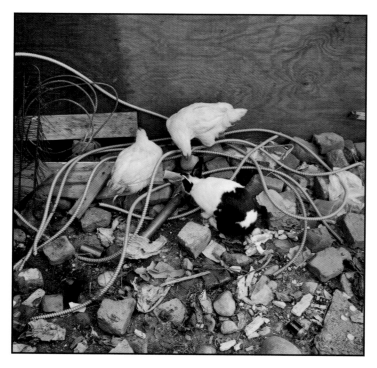

Juan, Bushville, 1991; Juan's animals, Bushville, 1991

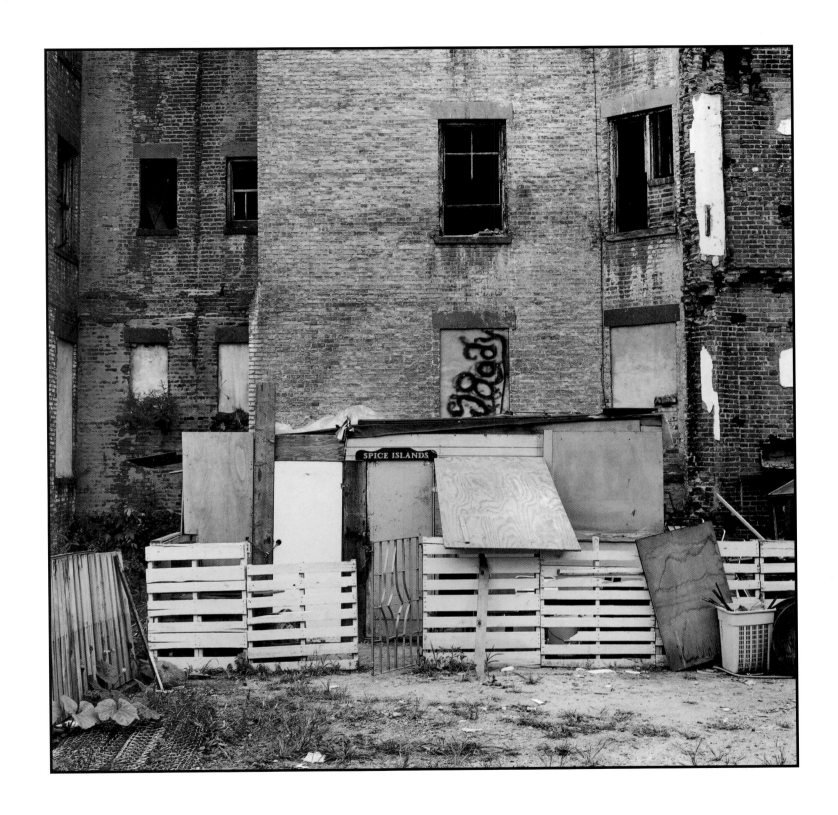

Juan's house, Bushville, 1991

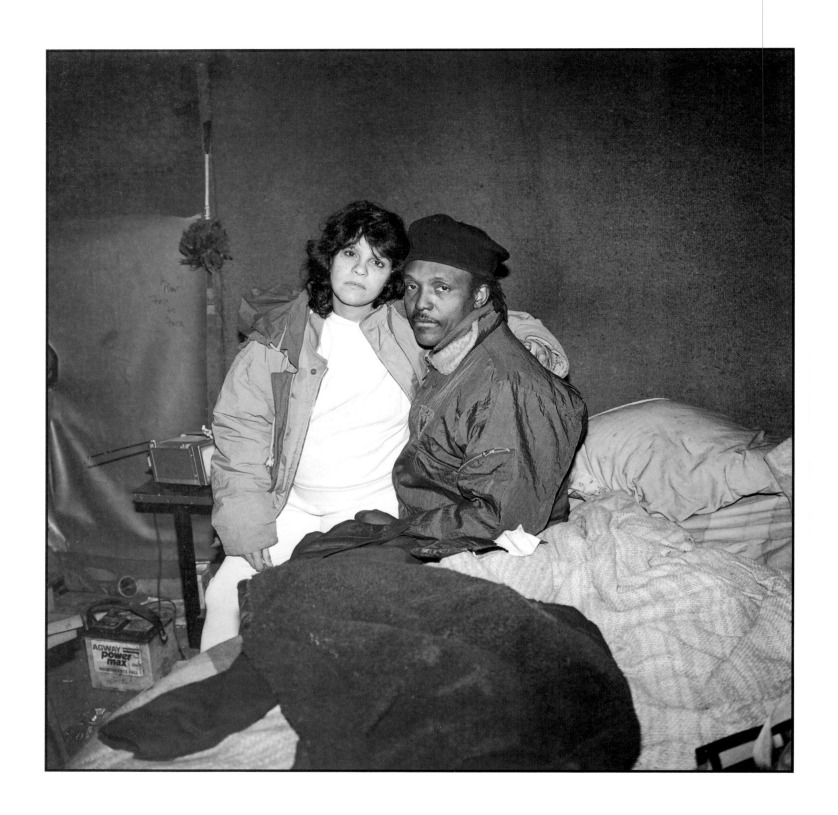

Tanya and Duke, Bushville, 1992 34

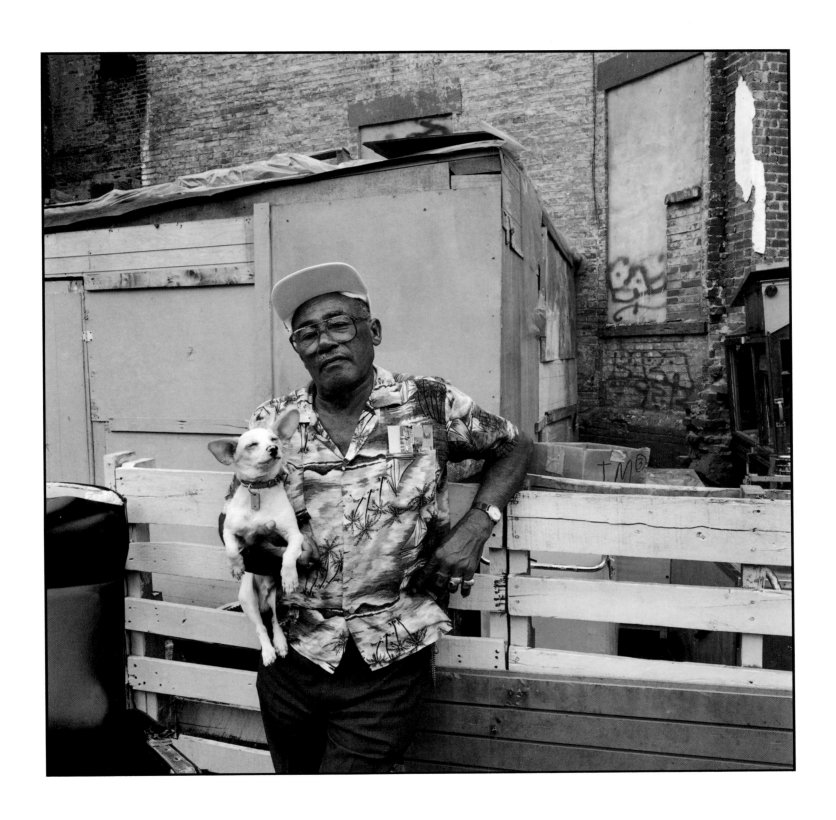

Gumercindo and his dog, Bush, on a visit, Bushville, 1991

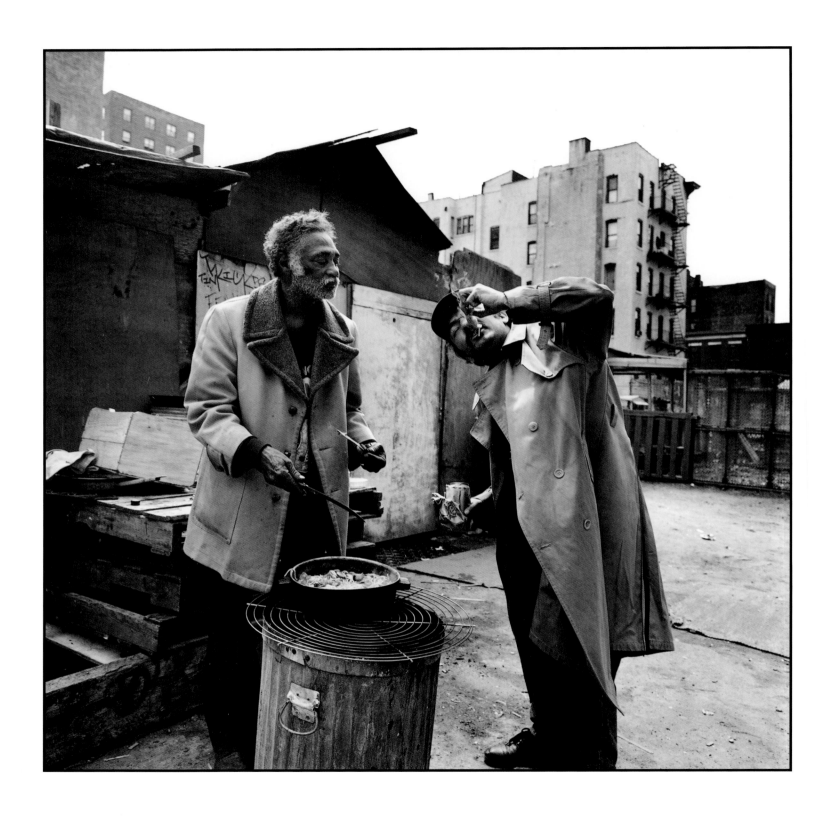

Mario and visitor, Bushville, 1993 36

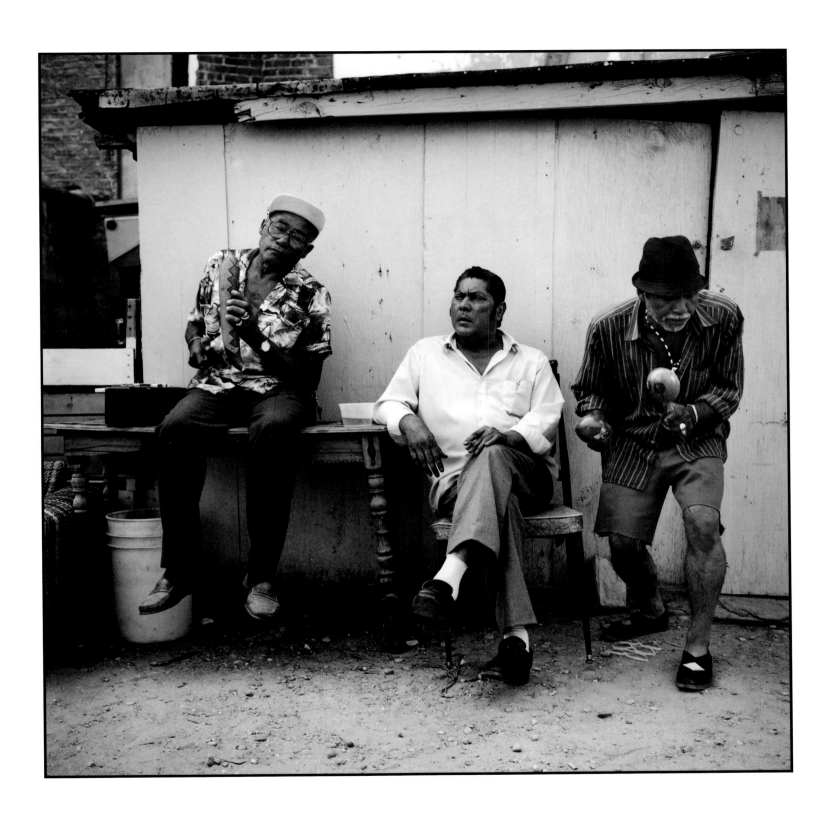

Gumercindo and Figueroa visiting Hector, Bushville, 1991

Spice Islands

Juan, one of Bushville's first residents, used the exterior wall of a deserted building as the fourth wall of his house. He fenced in a yard for his rabbits and chickens, and attached a plywood canopy to shelter his cooking grill. Juan prized a painted wood sign that he found and nailed over his front door: SPICE ISLANDS. Juan was found dead in his home in November 1991, a few days after he was released from the hospital. Gumercindo, who lived in a nearby apartment building, bought the house for forty dollars from Juan's widow, Evelyn, then rented it to Duke and Tanya for forty dollars a month. Tanya was four months pregnant, and Duke was anxious to find a more comfortable shelter than the plastic tent he had pitched beneath a ramp of the FDR Drive.

Duke

The guy said, "Well, I'll rent it to you real cheap. You'll just have to work on it yourself." So I cleaned it out, worked on the roof, and put the window in. Now I'm working on some heat. I was thinking about building a little fireplace. When we first moved in, a guy had died in here. You knew the guy. He stayed in here three days. Well, we've seen this guy in here a couple times—his spirit. Tanya has. I have. After that we never blew the candles out at night. Tanya won't spend the night here alone. That's why the place is haunted, because his spirit is restless.

Hector

Sooner or later—the city—they going to chop these houses down. I want to know, will they put something here for the people working hard? We suffer making the houses here. I would like to know if they are going to take care of those like me.

Duke

They said they're going to bring bulldozers and dumpsters and they're gonna clear this place away. Now I find myself in the mornings, about five or six o'clock, listening for some bulldozer to come creeping off some truck. It's like some monster and I know I have to get out of the way. It's gonna eat me up and I'll move on. But I've adapted myself to all the places and things I've done. I feel like after I got through the war in Vietnam, I can deal with all this stuff, even though it bothers you. When they come with the bulldozers and all that, I'll walk down the street, and I'll look back and say, "Okay, have it." I'm just going on to the next stage. You have to do that or you're going to go crazy with the bureaucracy stepping on you and people not caring about you. I built a pretty thick wall, and you know, it's not gonna bother me. Tanya was just saying last night, "They can't come without warning us, can they?" "Yeah," I said, "but we've been through that before." I try to get her ready, like, "Hey, don't worry about it." I've always had a place for her. I've made them all have a sort of home feeling, but this one had more.

Tanya

Everywhere we go, they wind up running us out and I have to start all over again. Duke always carries that tent he made from plastic. He carried that all the way from Sixth to Tenth Street, from Tenth Street to East River Park. That way I can sleep well.

In the early morning hours of December 15, 1993, Bushville was demolished. The residents were notified of the impending destruction but had nowhere else to go. As the bulldozers arrived, people quickly gathered their belongings. The noise of the heavy equipment was deafening, as massive shovels wrenched the small houses from their foundations, held them high, and then hurled them to the ground. Everyone scattered, seeking temporary shelter in doorways, abandoned cars, or with friends, while their homes fell splintered, piles of refuse once again.

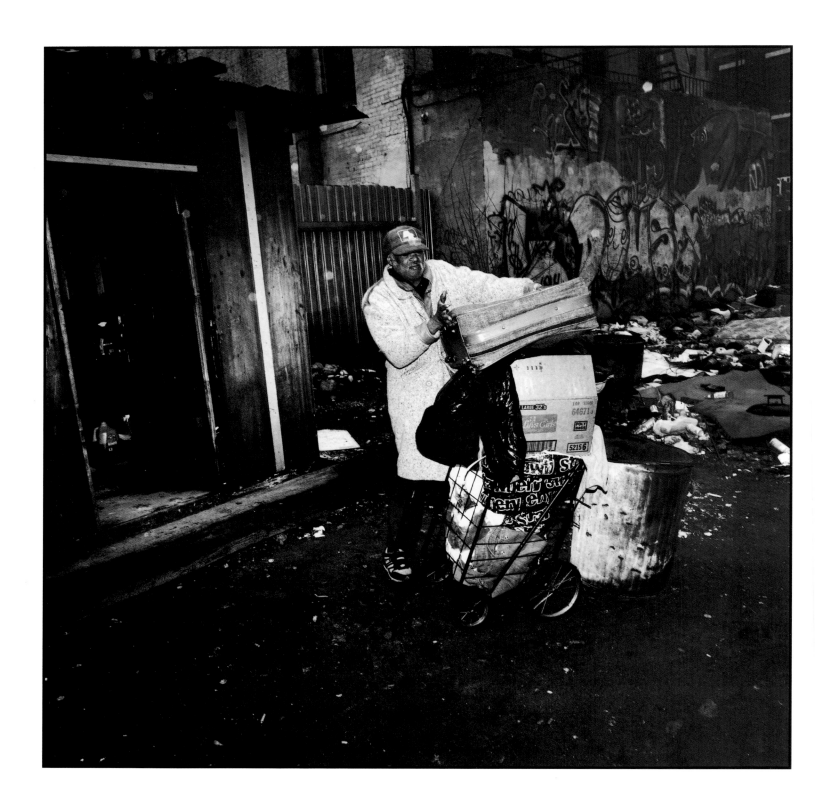

Mario, Bushville, 1993

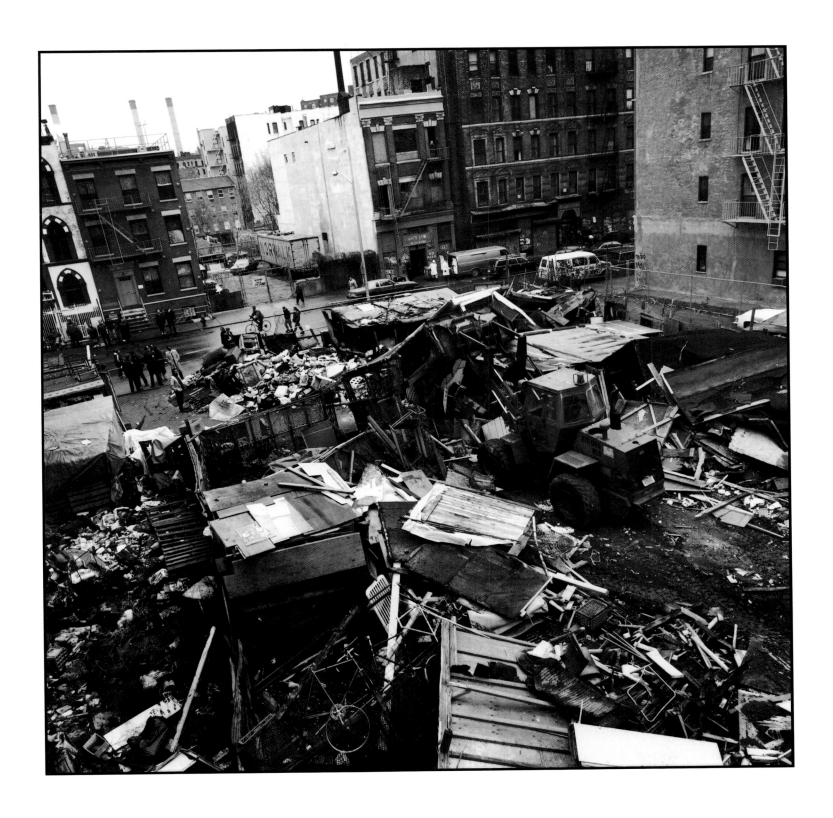

Demolition of Bushville, 1993

Jimmy's Fishpond

Jimmy bends down to pick through the rubble of an abandoned building on the Lower East Side. Patiently he selects fragments of brick to border an oval pond he has carved from the hard dirt of the sun-baked lot. The pond is six inches deep, lined with black plastic bags, and filled with water from a nearby fire hydrant. It seems boundless, cool, and magical despite the intense heat. A streak of orange suddenly breaks the surface and disappears.

There are only four goldfish right now. Teenage boys come into the lot and steal them. Sometimes they just leave them on the bank to die. But I always replace them—with what little money I get collecting cans.

In the back of the lot, Jimmy has pitched a tent, fenced a garden, and planted beans and corn. Leaning back in his chair, he recalls his childhood in the South: sunlight filtered through lace curtains, a piano in the parlor, a house overlooking a pond.

A week later Jimmy, his tent, his garden, and his goldfish pond have all vanished. The tracks of a bulldozer crisscross the lot.

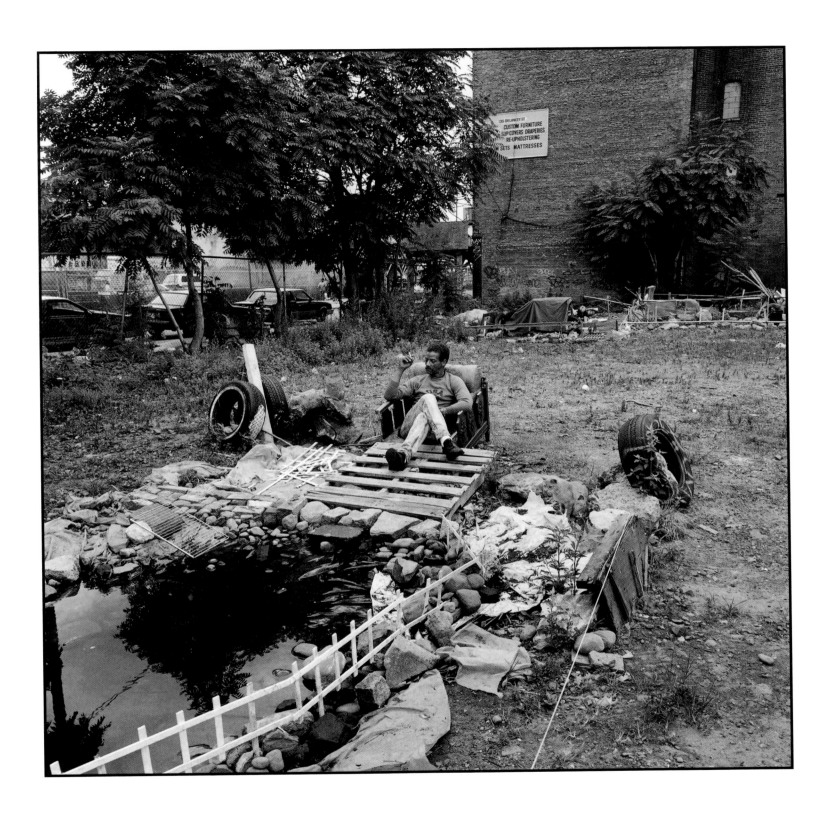

Jimmy, Norfolk and Broome Streets, 1991

Eighth Street Lots

On June 3, 1991, New York City riot police evicted 150 people from an encampment in Tompkins Square Park. Everyone fled immediately to two nearby vacant lots on East Eighth Street, rescuing only what possessions they could carry. As each person arrived, they claimed a spot with a cushion, piece of carpet, plastic tarpaulin, blanket, or bag of clothes. Then settlement began in earnest.

The new constructions were more solid and complex than those in Tompkins Square Park, where city rules required that sleeping accommodations, however makeshift, be dismantled each morning. Most people built plywood huts, some pitched plastic tents, while others shared sleeping quarters in an abandoned car. Two men ran electric wires from the base of a nearby streetlamp to power lights and television sets for the newly formed community.

When the summer heat becomes unbearable, one of the men attaches a showerhead to a six-foot length of pipe, then crosses the street to a fire hydrant: a quick turn of the wrench, a sputtering sound, then a spray of water sparkles in the sun. Just as quickly the men and women line up to take their turn bathing and cooling themselves. After an hour or so, the contraption is disconnected and disappears into one of the shacks for safekeeping. The only sign of the furtive showers is a stream of soapy water coursing down the street.

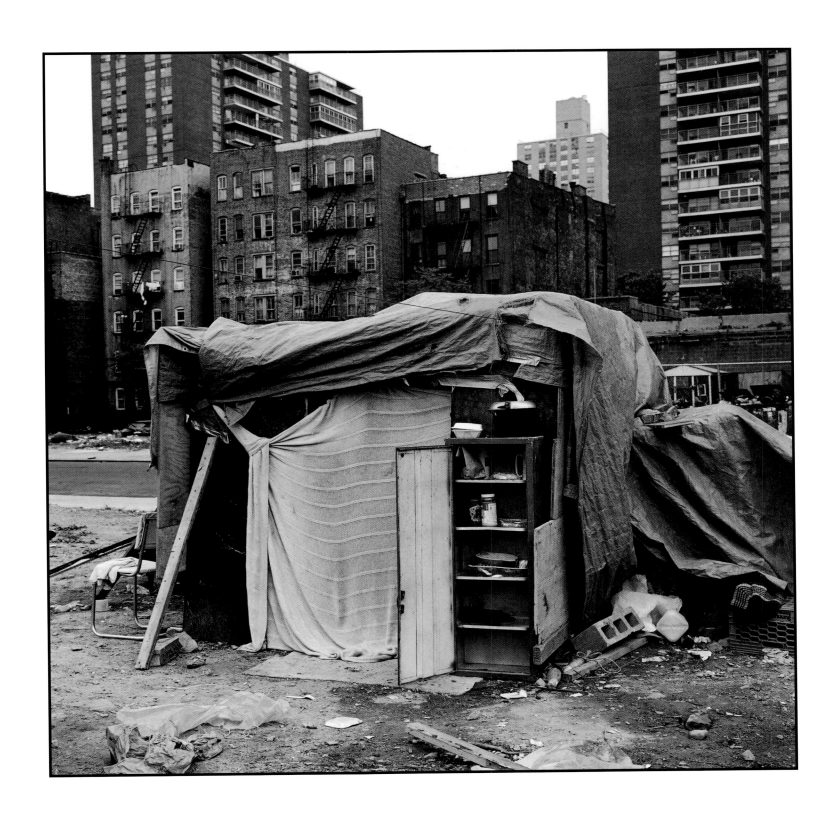

Rasta's house, East Ninth Street, 1991

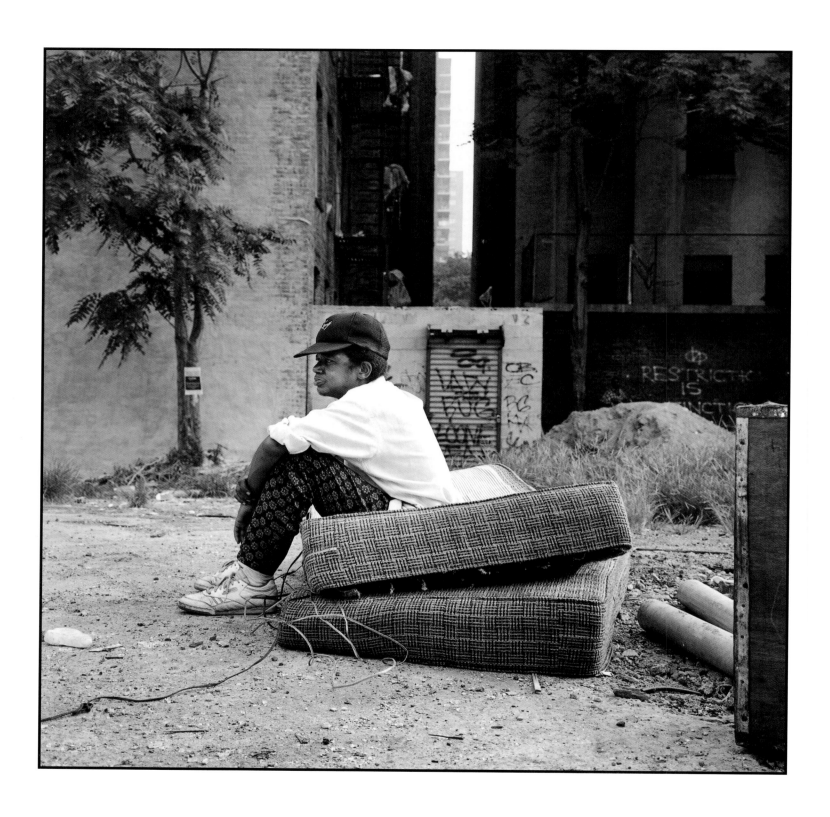

Deanna, East Eighth Street, 1991

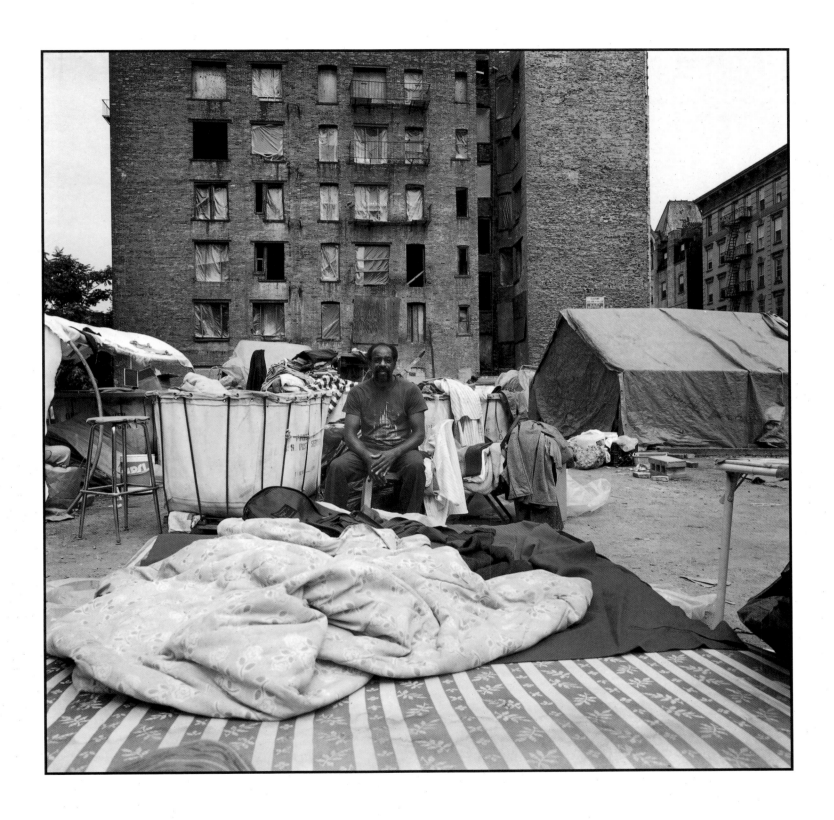

Rice, East Eighth Street, 1991

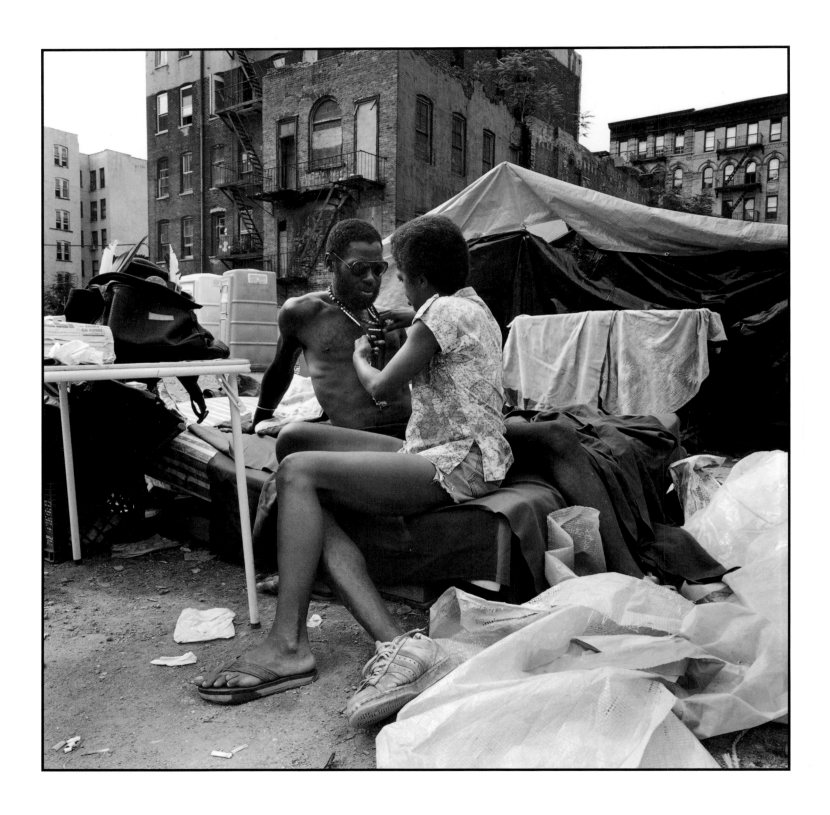

Terry and Deanna, East Eighth Street, 1991 48

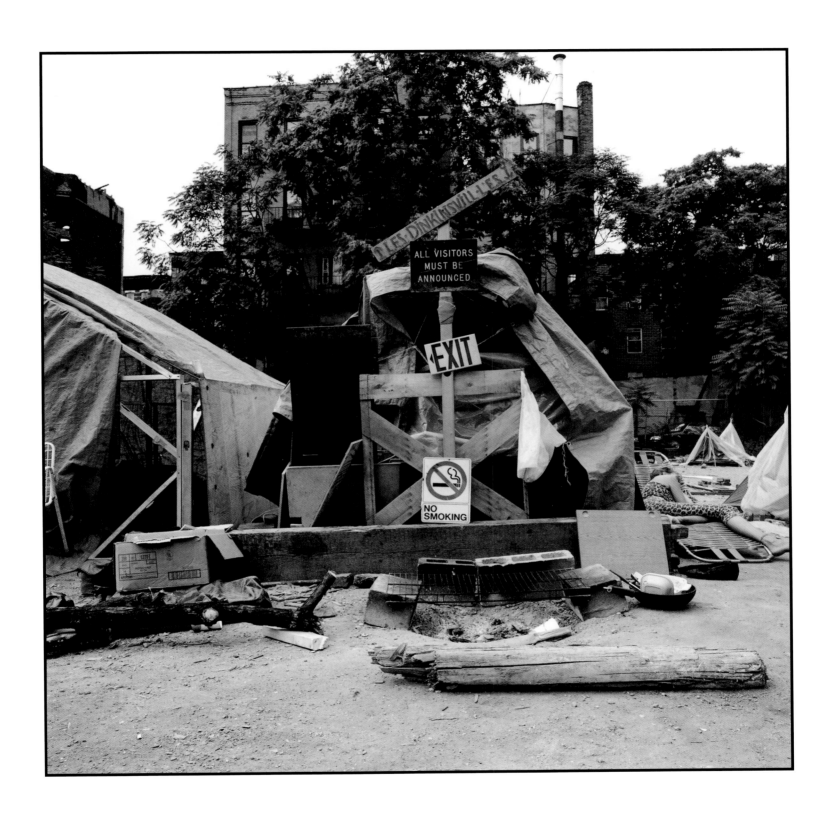

Reni's tent, East Eighth Street, 1991

Moses

I used to live in Tompkins Square Park, back in 1987. They run us out of there one morning, and now I'm living in the Eighth Street lot. I've been there close to a year now. I find that instead of living in a shelter, I would rather build my own little tent. The advantage is that sometimes you find a mattress, a chair, and you can put it inside your tent and make it like a home. We all know each other; we socialize. We use fire hydrants to drink water or wash ourselves. I have found so much stuff in garbage cans. I've found nice shoes, nice clothes.

I've lived in a men's shelter. It's worse than a prison. A man can't live like that. First of all, men need a private room; they need a sink, they need a sanctuary—not in an open place where they're ushered around by security guards.

I want to build me another tent, another house. Get me some skids for the ground and then build the sides up with two-by-fours, build a roof, and get some tar paper on top of it. I might build me a little fireplace. It would probably take a good three, four weeks. [Points across the lot.] *They got a place over there. They got everything: electricity, water. Something like I want. But these people build something a little bit better.*

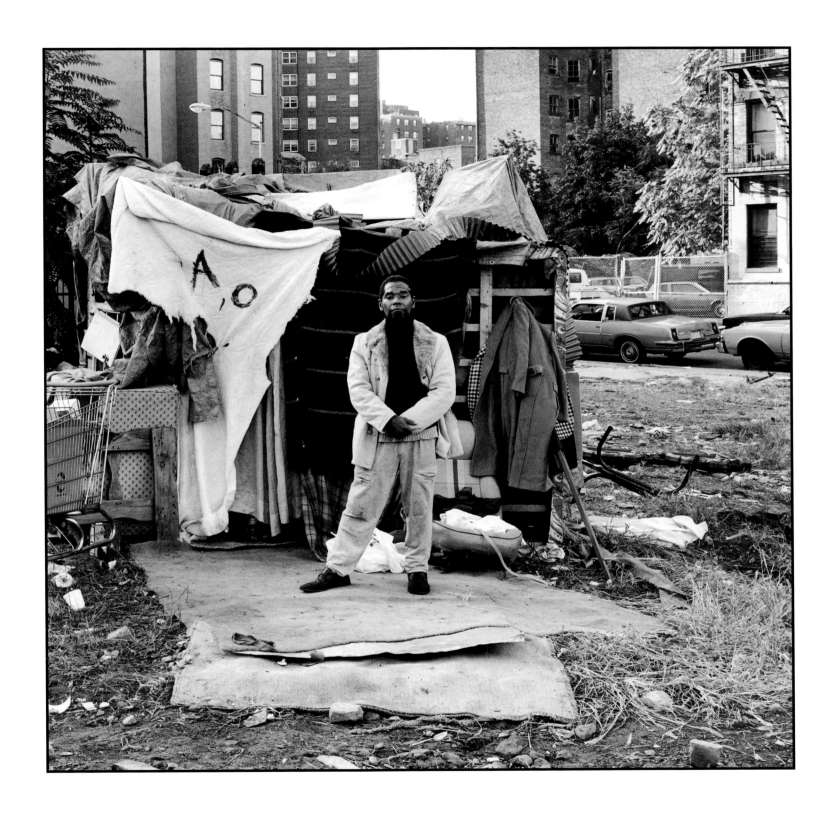

Moses, East Ninth Street, 1991

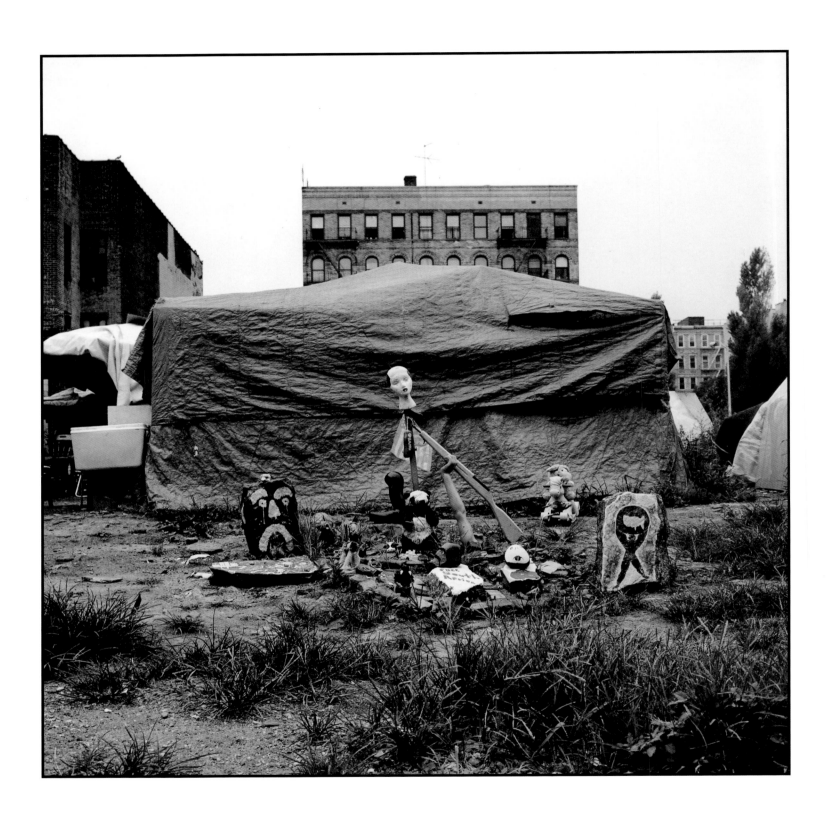

James's tent and garden, East Ninth Street, 1991

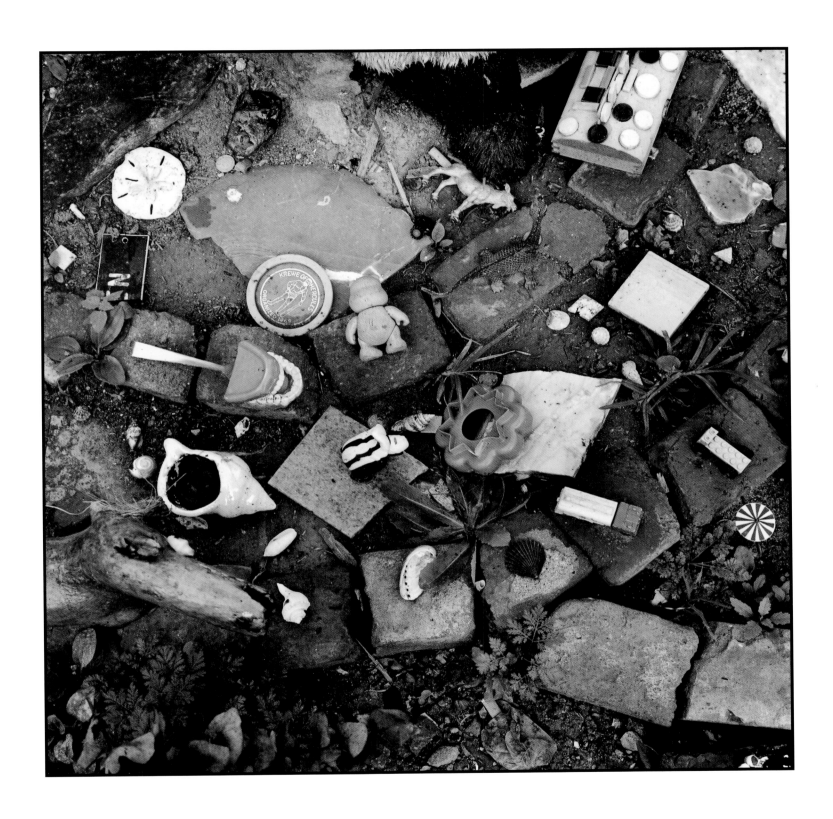

James's garden, East Ninth Street, 1991

The Hill

COMFORT FURNITURE, CELEBRATE THE YEAR OF THE LOAN, WE BUY GOLD
AND SILVER, [212] B-E-E-P-E-R-S, WE ALSO SELL SOFAS, TOTALLY KOOL. These
billboards, promoting the comforts of home, quick cash, and the good life, target commuters
crossing the Manhattan Bridge. The displays also frame a shantytown, known as the Hill,
on a triangular plot of land alongside the Canal Street off-ramp.

Signs, smaller but no less insistent than the gigantic ads overhead, appear throughout the Hill.
KEEP OUT OF THIS HOUSE, in furious brushstrokes, fills a plywood door. DO NOT CROSS,
a doorsill fashioned from a blue police barricade, reinforces the warning. ACE'S PLACE is
scrawled in black paint on a recently constructed shack. Chinese calligraphy completely covers
one rounded hut. A nineteen-foot tepee, erected by two artists, is stretched with canvas bags
stenciled DOMESTIC US MAIL.

A large sign, salvaged from the neighborhood and affixed to a shack, announces WE'VE MOVED
TO 47 DELANCEY ST. NEXT BUILDING. A wooden cross hand-painted PUFFY and
PETTI SNOW commemorates two cats who made the mistake of venturing onto Canal Street.
A signpost, IN MEMORY OF EDDIE EBERSOLE, stands alongside Eddie's former hut.
FATHER HURT is the bold title of a poem of childhood anguish. A long white banner, tied
to a chain-link fence, faces Canal Street: PLEASE SEND HELP.

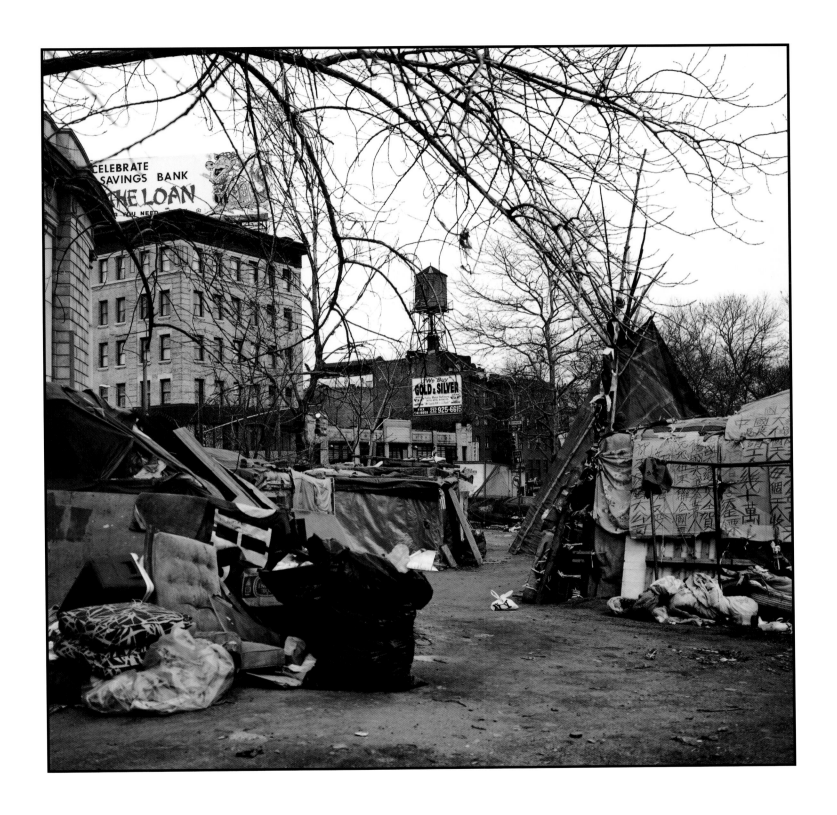

The Hill, Chinatown, 1991

Louie

We used to call this Rats Hotel. Nobody was up here except for about six of us. We used to bring mattresses and throw them down on the ground. There used to be weeds here taller than we were, and thousands of rats. We'd lay there and just drink our beer, talk our drunken talk, and fantasize about this or that. Off and on, I would get myself together, sober up, and leave for a few months. Eventually I came back and there was one shack here. Somebody had moved in. And it just kept accumulating until now you can't hardly breathe in here.

I built that house for him [indicates Shaft's first house]. *I painted it brown. And I don't think I got paid for it. You take a piece of plywood that's four feet wide, eight feet high. So you build a shack exactly eight feet by eight feet and you don't have to cut no wood, especially when you got no electricity.*

All those places on the right, I built them. So many of the shacks I built have burned down; I can't keep track of the number. Used to be fairly peaceful, but there's too many people now. Too many old junkie shacks, the drug addicts going in and out. I'm looking for a new spot. But there's no place that I've seen—and I do a lot of walking, too.

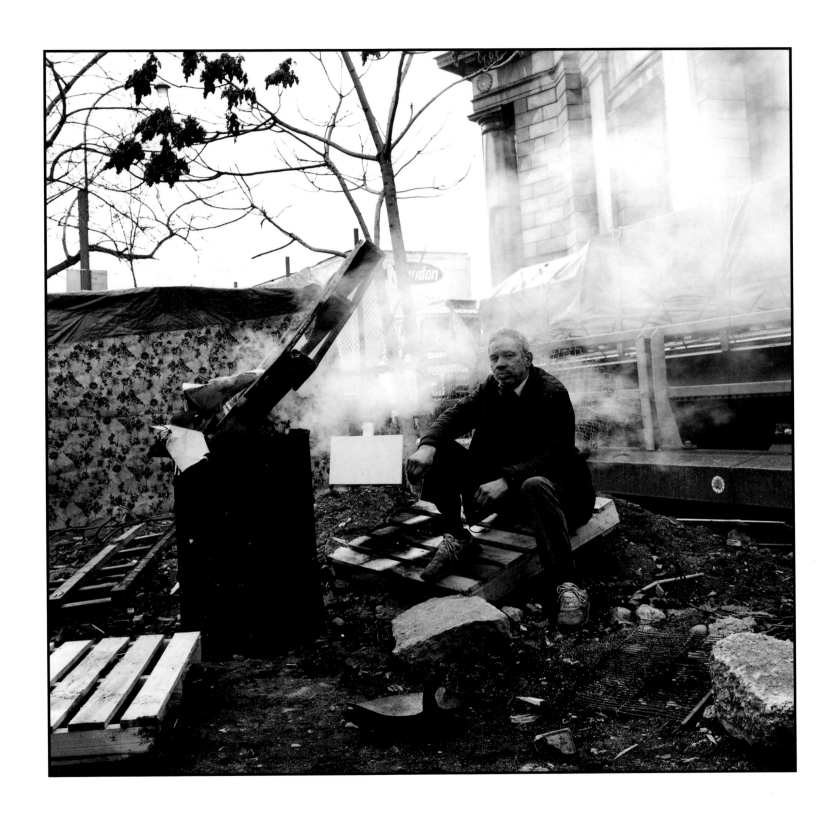

Louie, the Hill, 1991

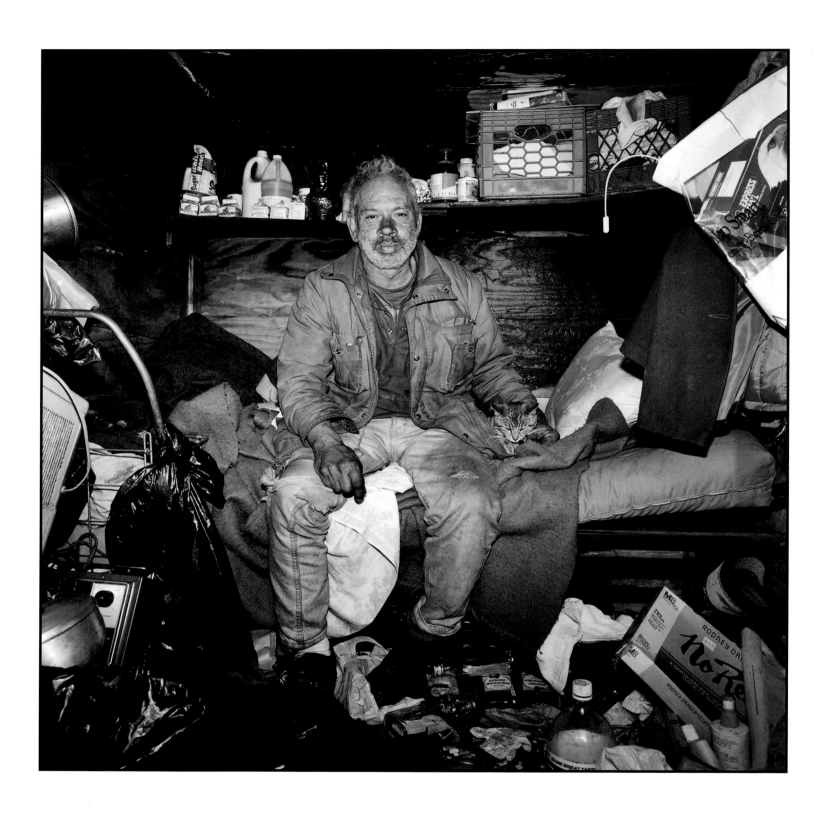

Louie with kitten, the Hill, 1992

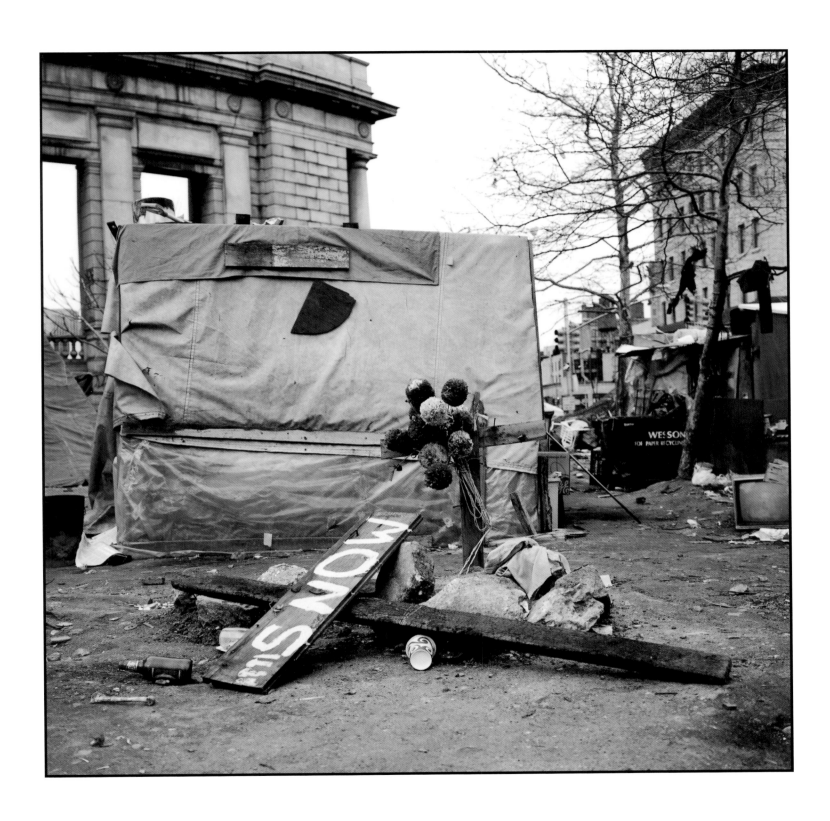

Louie's pet cemetery, the Hill, 1991

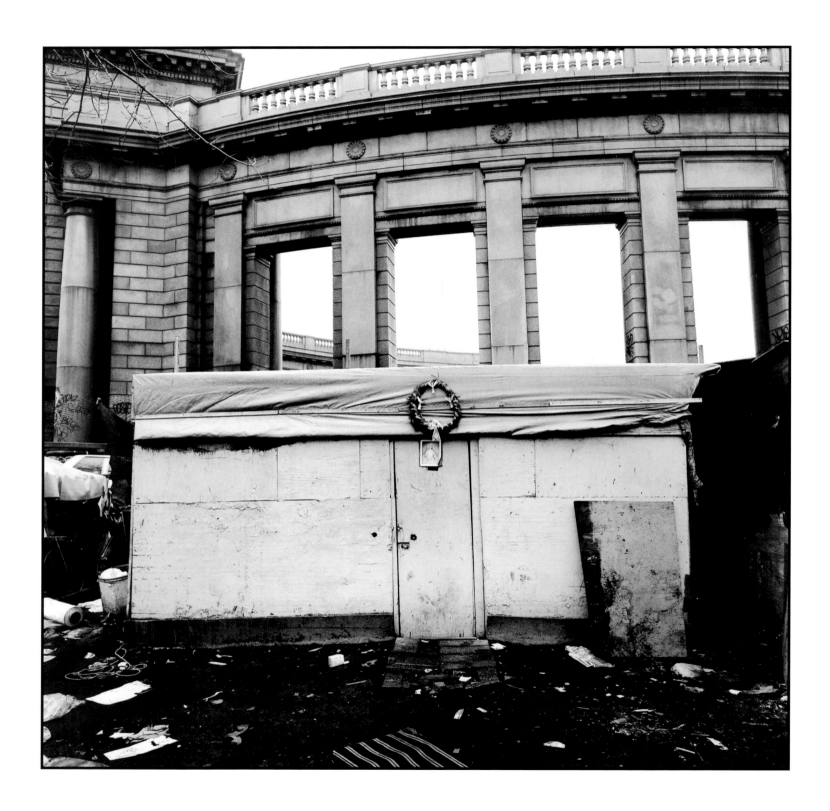

Shaft and Lisa's house, the Hill, 1993 60

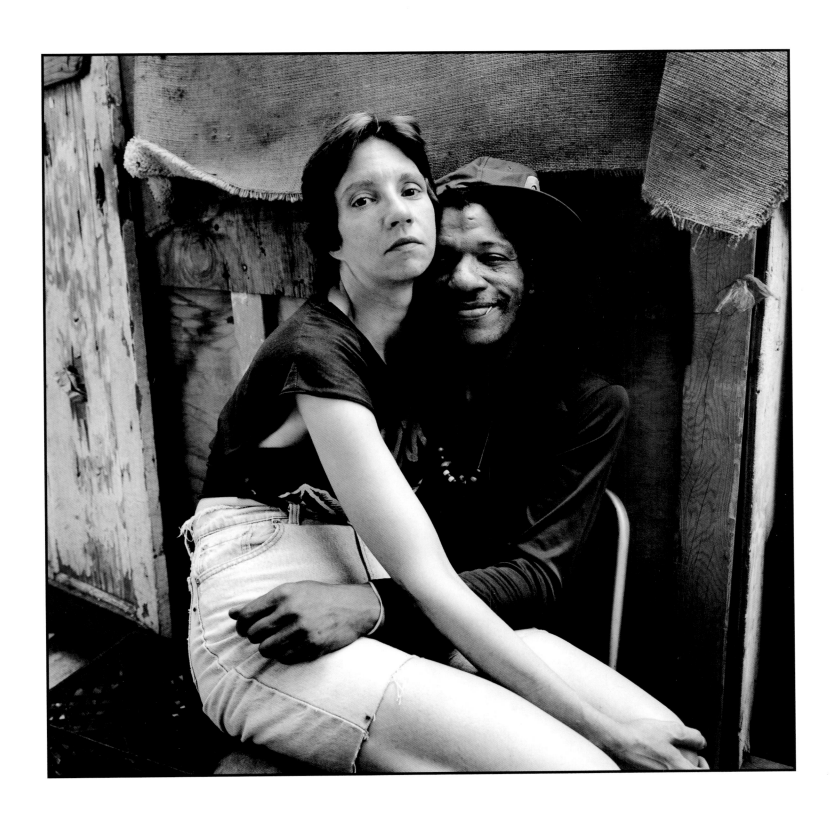

Barbara and Ace, the Hill, 1992

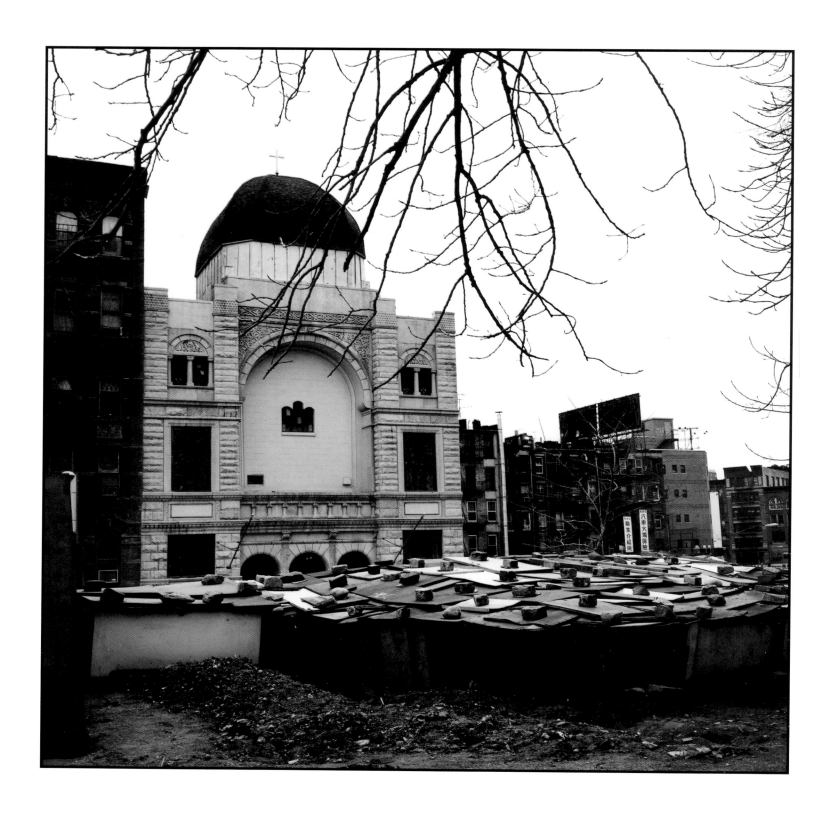

Roof of Sam Wong's house, the Hill, 1991

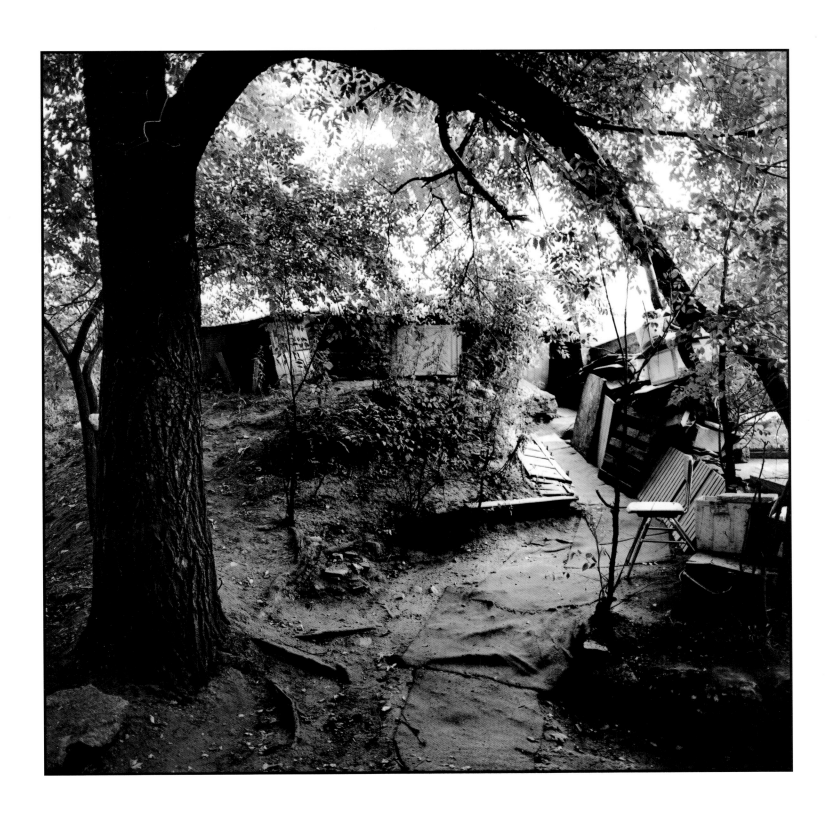

Sam Wong's house, the Hill, 1992 63

Barbara

Ace and I have been friends for years, on and off. Then we go off to our own little thing. When I came from Jersey I was going up [to the Hill] to get high. I still had my car and I'd bring some of the people up there, and Ace was living up there in the corner, and we just got to be friends. We ended up staying together. If I ever needed help or anything, Ace would be there. He's a good friend. When Ace got stabbed in the neck, I went across the street, called the ambulance, and went with him to the hospital.

Ace

I was born in Philadelphia, but I'd been coming back [to New York] for nine years. In 1981 I came back and stayed back. I was working on 150th and Eighth Avenue at a toy manufacturer. I worked there two years. It went out of business, so I moved to the Bronx and worked as a mover for three years. Then I went back to Philadelphia for one year. In 1987 I came back to New York and started working for a Chinese plumbing supplier. I lived at 145th and Seventh Avenue in a kitchenette. I commuted to Chinatown for a year. I was married but having problems, and was staying in a shelter. I kept the job at the plumbing supply, but I was homeless. First I lived in a park near the Hill for six months, then in 1988 I moved to the Hill and built a hut. The Chinese man was already there.

Mr. Lee

At the crest of the Hill, just before it narrows to a ravine and plummets toward Forsyth Street, stands the curious home of Mr. Lee, an immigrant from Guangdong Province in China, who found his way to the encampment in 1989. He brought few possessions but soon astonished his neighbors by constructing a house without pounding a nail or sawing a board. It is bound together with knots. Bright yellow plastic straps wrap his soft rounded hut, binding old mattresses and bedsprings into walls. The exterior is festooned with red bakery ribbons, paper lanterns, and castoff calendars that celebrate the Chinese New Year. Oranges, symbols of prosperity, have hardened in the bitter cold and hang from the straps like ornaments.

Every morning, Mr. Lee quietly draws Chinese characters on flat sheets of cardboard and lashes them to the outside of his hut: CONGRATULATIONS TO MR. LEE FOR HAVING A BIG COMPANY, HE HAS HUNDREDS OF THOUSANDS OF WORKERS, EACH WORKER GETS PAID $500 A DAY, PROSPERITY TO MR. LEE, MR. LEE THE GREAT INVENTOR. He does not write about the job he once held as a restaurant worker in Queens, or about his last apartment, a walk-up on Mott Street.

At dawn, when Mr. Lee leaves the Hill, he places a stone against his door and secures it with elaborate knots. He slowly wanders the streets of Chinatown with two burlap rice sacks slung over his shoulder, pausing to collect bits of cloth and cord left by morning delivery trucks. In the early evening he returns and, with great ceremony, ties his new treasures to the exterior of his hut. Mr. Lee sometimes binds these objects in such a way that they take on new forms and identities. The majestic cluster of fruit perched atop his roof is in fact a teddy bear, which he found on the street and skillfully transformed.

Much like his house, Mr. Lee is soft and round and held together by knots. Bits of wire twisted through buttonholes fasten his multiple layers of second-hand clothing.

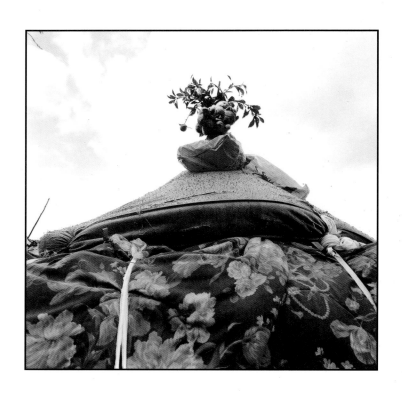

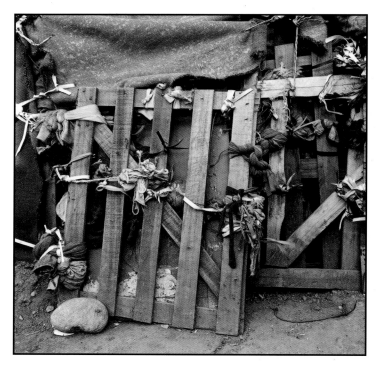

Roof of Mr. Lee's house, the Hill, 1992; Door, 1992

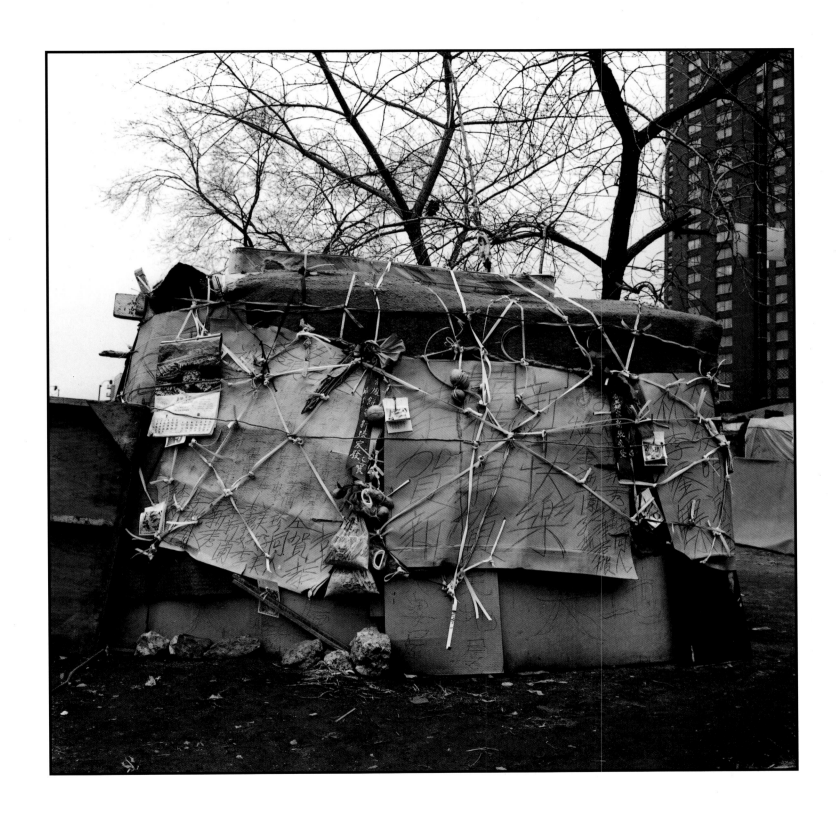

Mr. Lee's house, the Hill, 1991

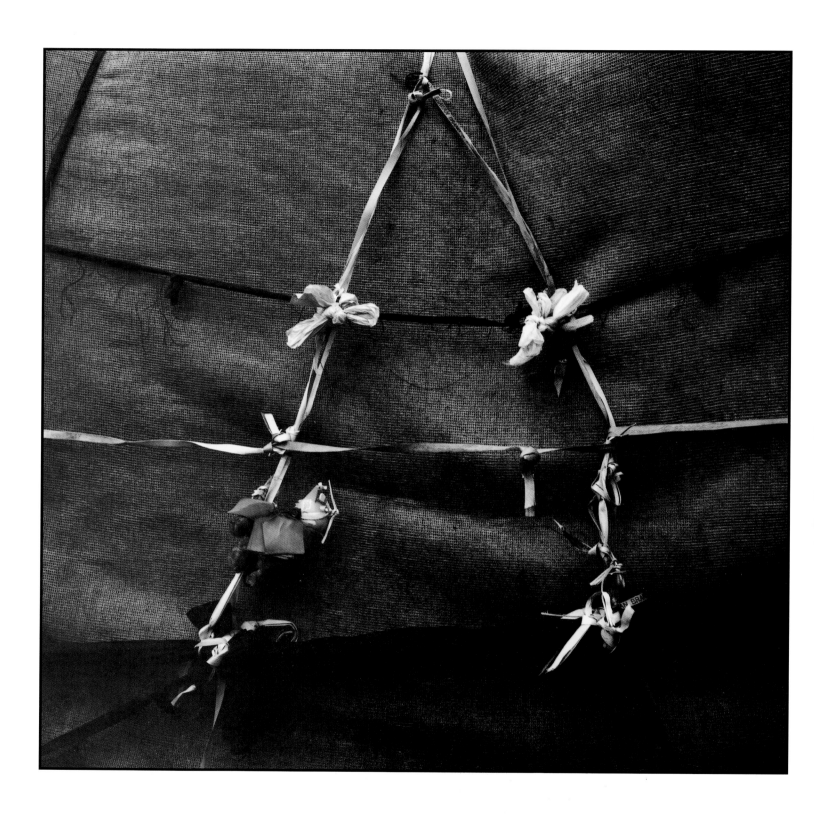

Knots on Mr. Lee's house, the Hill, 1992

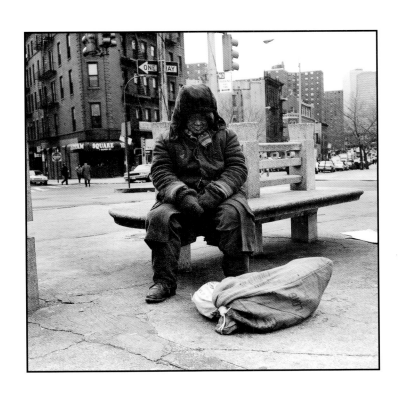

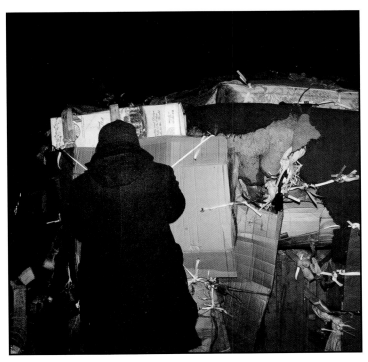

Mr. Lee, Chinatown, 1992; Mr. Lee, the Hill, 1992

Mr. Lee died in his home on May 29, 1992, in a fire set by an arsonist trying to get even with another resident. Detectives searching through the ashes found bundles of charred photographs of Chinese families; handcrafted passports for imaginary relatives, all named Lee; and a large slate inscribed with cryptic ideograms.

In the months that followed, every attempt to build on the site of Mr. Lee's house of mysterious knots and messages was also consumed by flames. After another rash of fires, the city demolished the settlement on August 17, 1993.

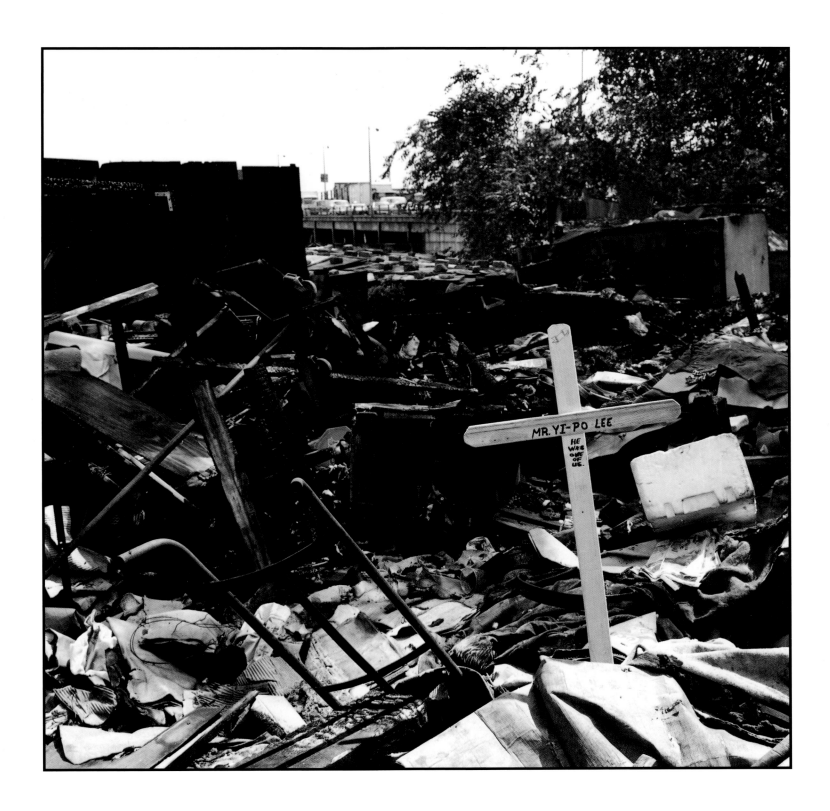

Memorial for Mr. Lee, the Hill, 1992

The East River

In the late 1980s, a group of homeless men pieced together a row of plywood shanties along the seawall that borders the East River between the Manhattan and Brooklyn bridges. Several of the men had been evicted from Tompkins Square Park. Others had been expelled from vacant lots, public parks, or abandoned buildings. Two of them had fled the arched ramparts of the Brooklyn Bridge; another had been routed from an underground tunnel. Some sought respite from the city's shelter system. Others sought asylum from oppressive regimes.

The sunrise offers solace; the community offers stability. Wooden pallets, discarded from local delivery trucks, provide fuel and building material. Residents of neighboring projects discard an endless supply of cans, which the men redeem for a nickel apiece. Eight years pass. The improvised dwellings are transformed into more permanent structures that evoke memories of home: a roof of the same pitch, a duplicate front door, a porch railing made of rope, a nameplate over the entrance, a weather vane. The population grows to thirty-five. Girlfriends arrive. Stray cats and dogs are adopted as pets.

The FDR Drive, high above, casts an enormous shadow upon the small village. Perhaps it is the incessant roar of cars that deafens the more subtle sound of the river's changing currents. No one is prepared when the bulldozers come on July 1, 1996. For those who considered this home, the dream is shattered. Everyone moves on.

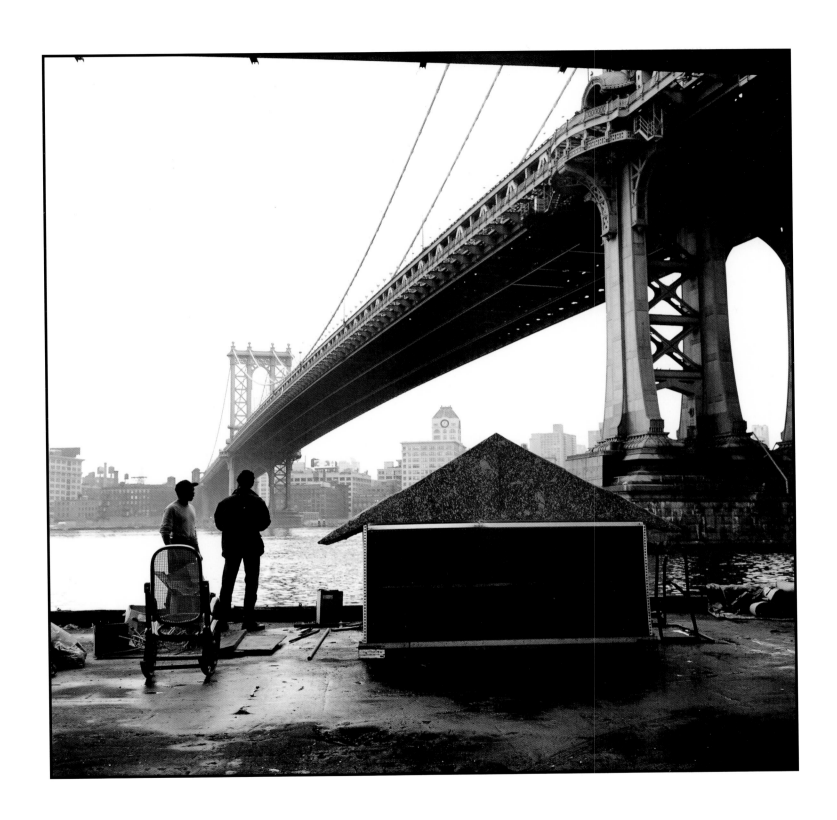

Mac's first house, East River, 1992

Mac

I grew up in the South in a house that faced a river. I had a complete carpentry course in high school, but I improvise when I'm doing things here. I built this house in one day, really. When I started I was just trying to keep it a refuge from the elements, and then I kind of reinforced it a little bit every now and then. You've got your basics—insulation and waterproofing. The location isn't soundproof, so you can hear the birds tweetin'.

Mark

Just a stroke of luck. The same door. A little piece of home. That was a find I'll never forget. It was in a dumpster over in the East Village, where I find a lot of stuff. Someday my mother will see the door and say, "I got a door like that too." I'm no more vulnerable than anybody that has an apartment or a house. I mean, just like them I have a door.

Slim

This is where I get my serenity, where I get my thoughts together. The water and I have a lot of conversations. It don't answer me back, but I can talk to it. It's a beautiful sight. At nighttime it's even more beautiful because the lights are on and you can't see the junkiness out here like you do in the daytime. At night it be all nice and peaceful.

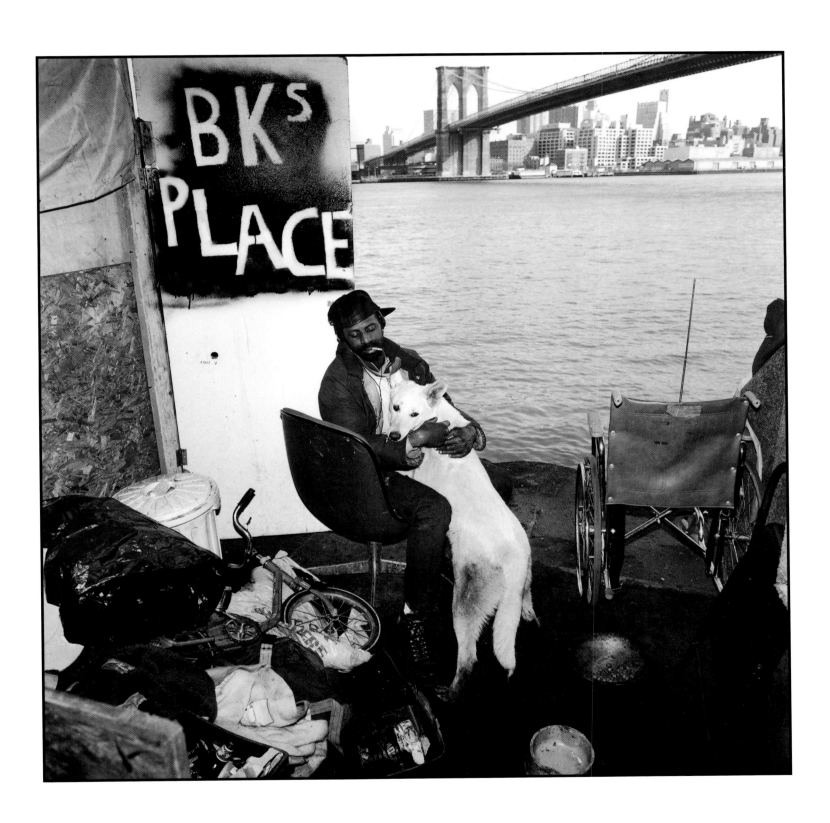

BK and his dog, Poochie, East River, 1994

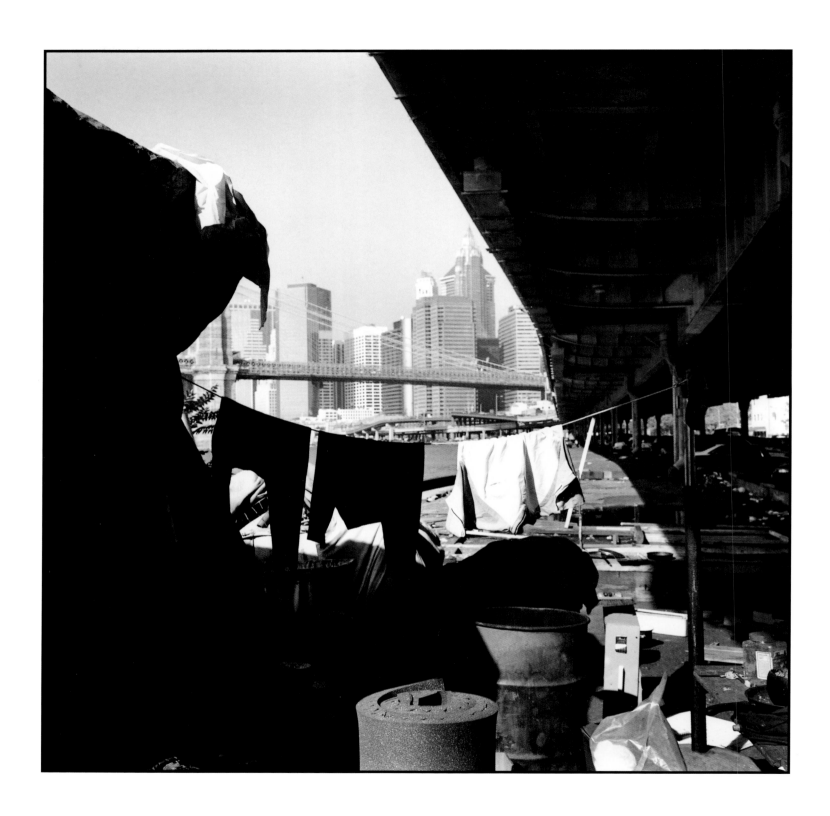

Chrissy's laundry, East River, 1993

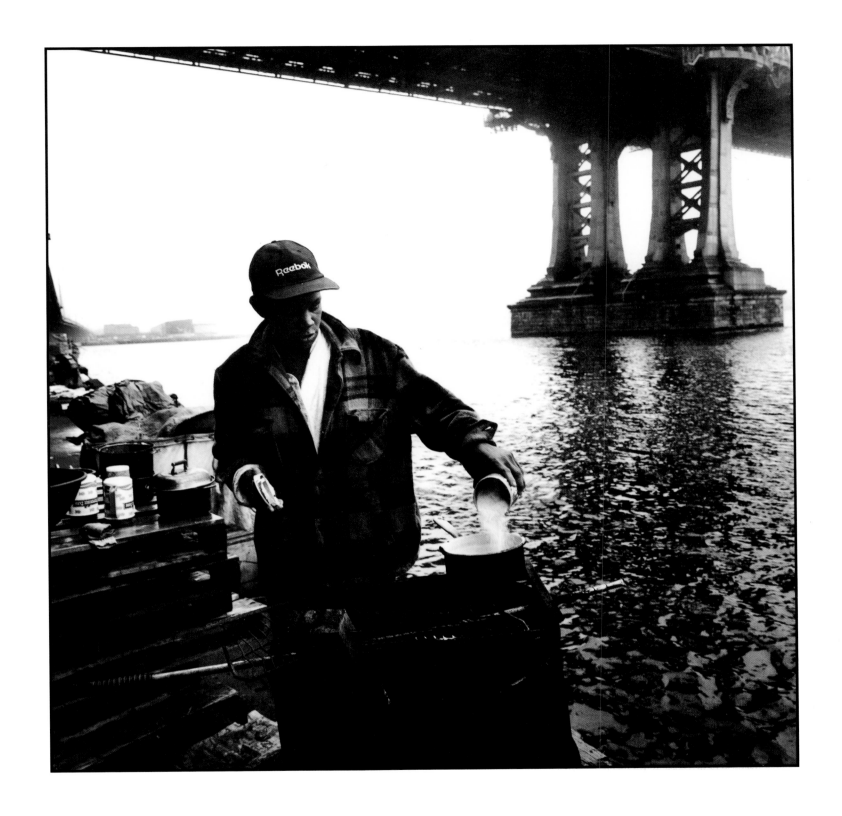

Hettie, East River, 1993

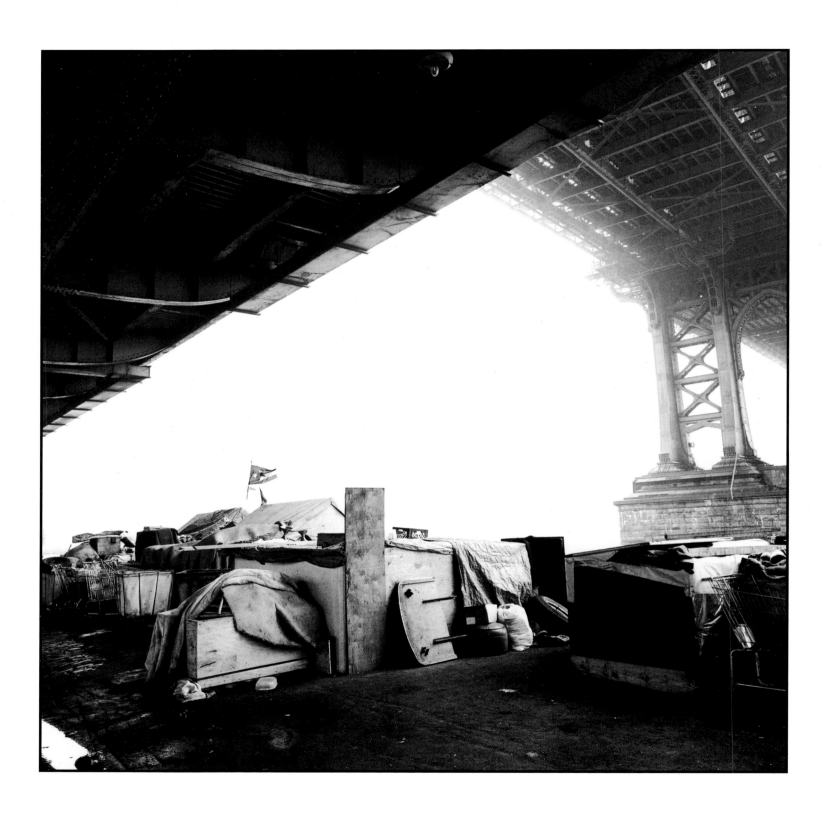

Huts with Puerto Rican flag, East River, 1993

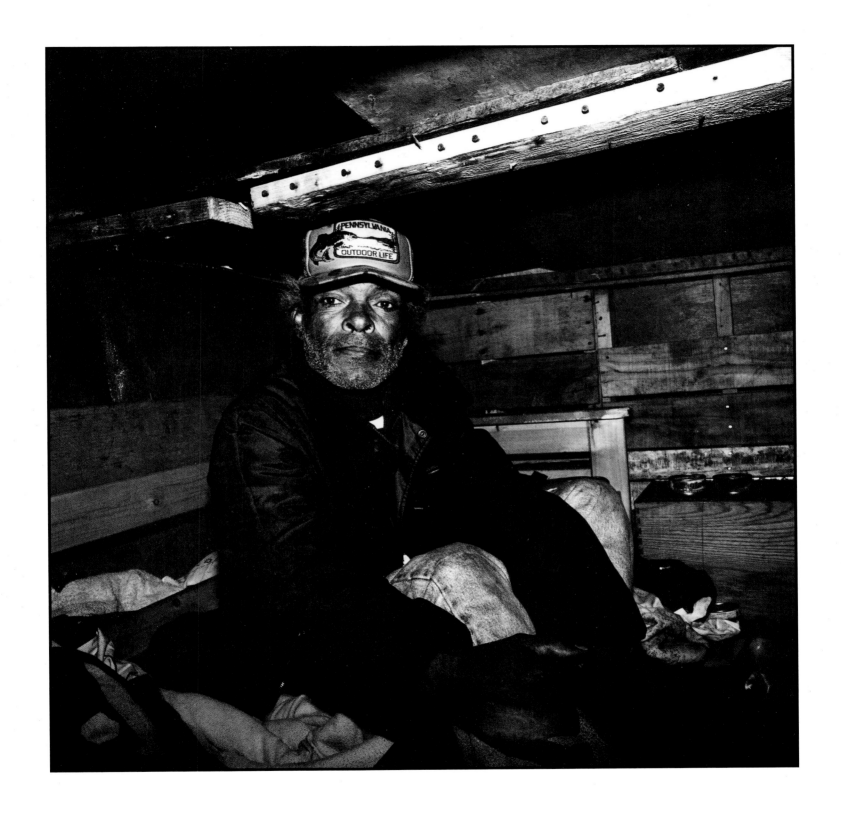

Maurice, East River, 1994

Mizan

C, Sammy, and I started the house. Sammy, Doug, and I finished it after C moved on. Jimmy drifted: sometimes he slept here, sometimes at Flaco's camp, sometimes he slept outside. I planned the skylight from the beginning so that we could bring the fire barrel inside. We always kept a pan of hot water on the side, for washing up.

Doug

You may drive by here and see that they are shabby, but I think that if you look again you see this person took the time to build a place that could be comfortable for himself. If you saw it up close, you could see that we'd turned it into a home. I've come to find out that it puts you more in touch with your spirit, too, because you realize it's not always about the money; it's really about getting an idea of who you are. When we finished reconstructing this place, it stopped looking like a dump. That was good because it builds up your self-esteem, and it's easy for that to fall. It took character to build this, a sense of pride. The person who will take the time to build for himself is the person who still has an interest in himself. And then other people come along and get the idea, and they start building too.

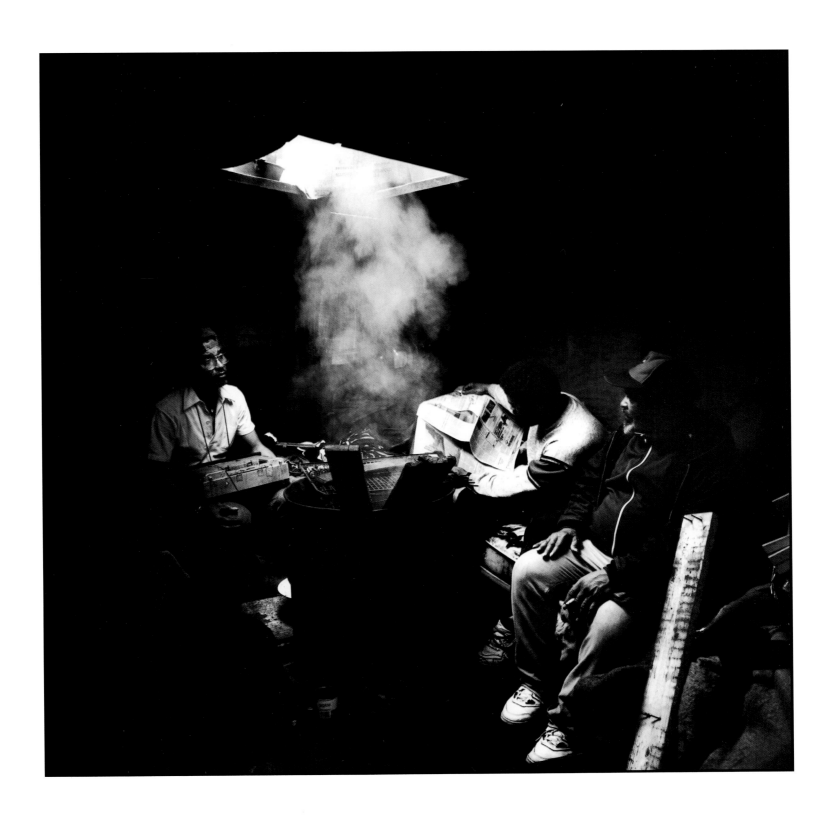

Mizan, Doug, and Jimmy, East River, 1993

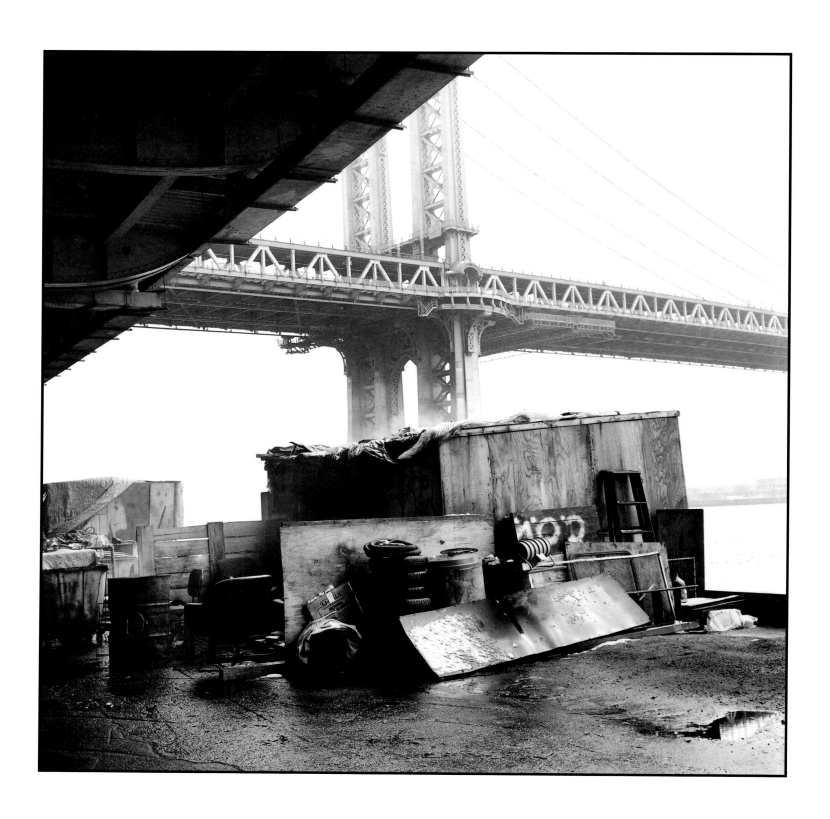

Doug and Mizan's house, East River, 1993

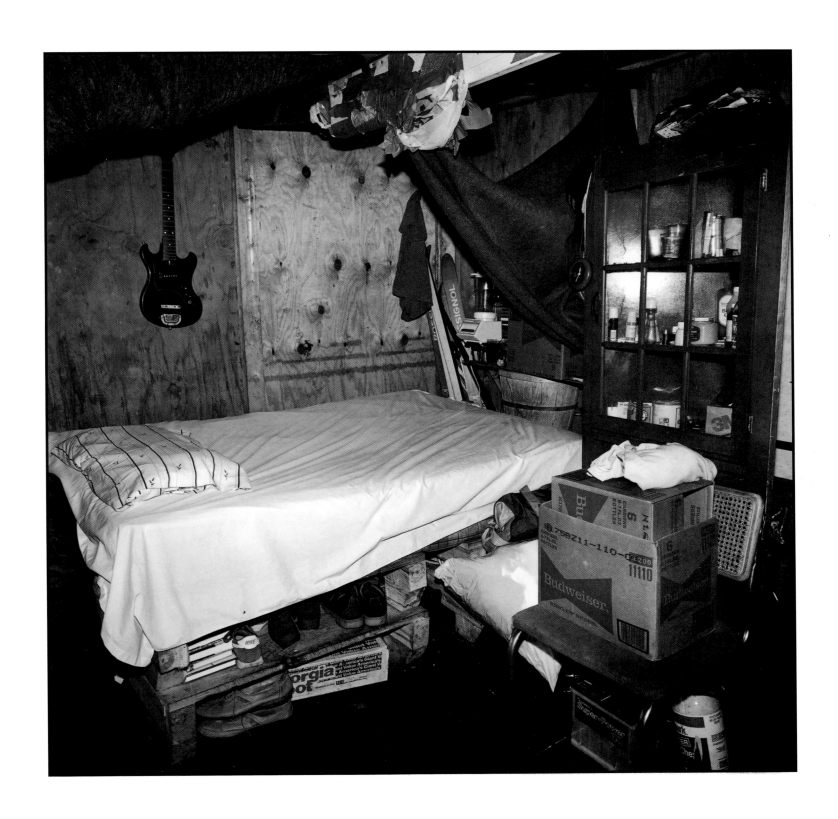

Doug's house, East River, 1992

Marian

I was born in Warsaw. My friend had a radio station at my house. He and two other guys went to jail. His mother said, "Marian, you got to leave the country." I left for Germany, then I came here. I found a job as a construction worker, then the boss said business was slow. No more job. Then somebody robbed me and stole my immigration papers, my passport, my job permit, everything. Now nobody will take me for a job.

I couldn't pay the rent, so I moved to the street. First I was sleeping in the subway. Later I found a place in an empty building, but one day the cops came. Sometimes before, I saw people who picked up the cans. I picked up my first can. I was ashamed, but I was hungry, I was broke. I made one dollar twenty-five. I was so happy. Then I found a job Midtown. I'd take a shower at night, outside in the snow, because you've got to be clean. I was working there three weeks, then I said, "I can't manage." It was too much.

I stay with Joseph, Maurice, one Spanish guy, and other guys. We've known each other for a long time. But this is street life. Everybody's thinking about money. With food it's not a problem. If you're cooking, you share it. Everybody does that. Cigarettes are a different thing. Cigarettes are money.

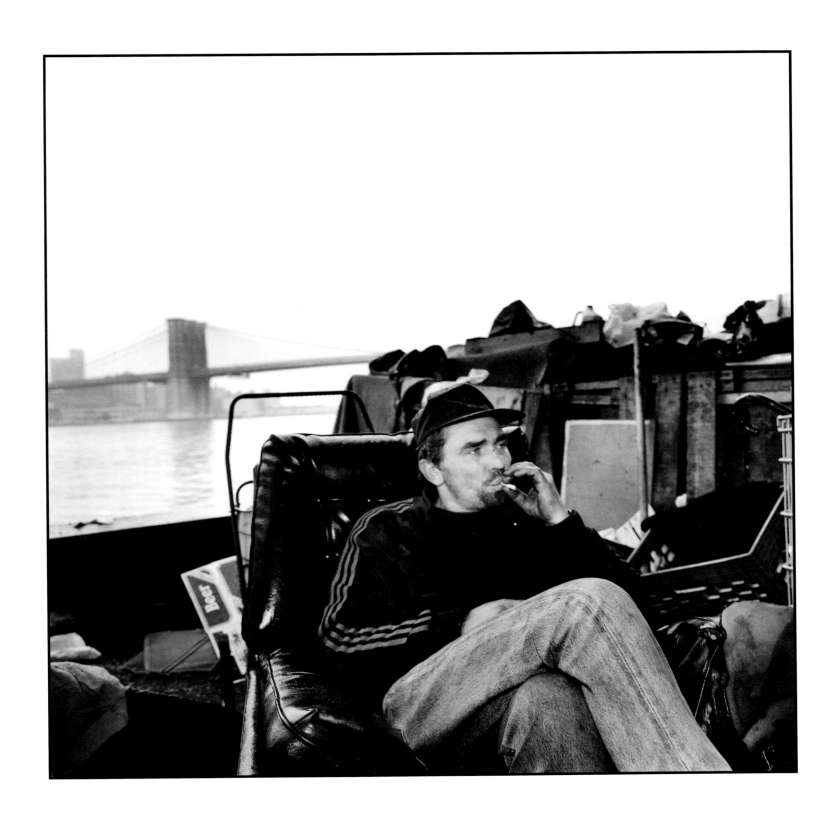

Marian, East River, 1994

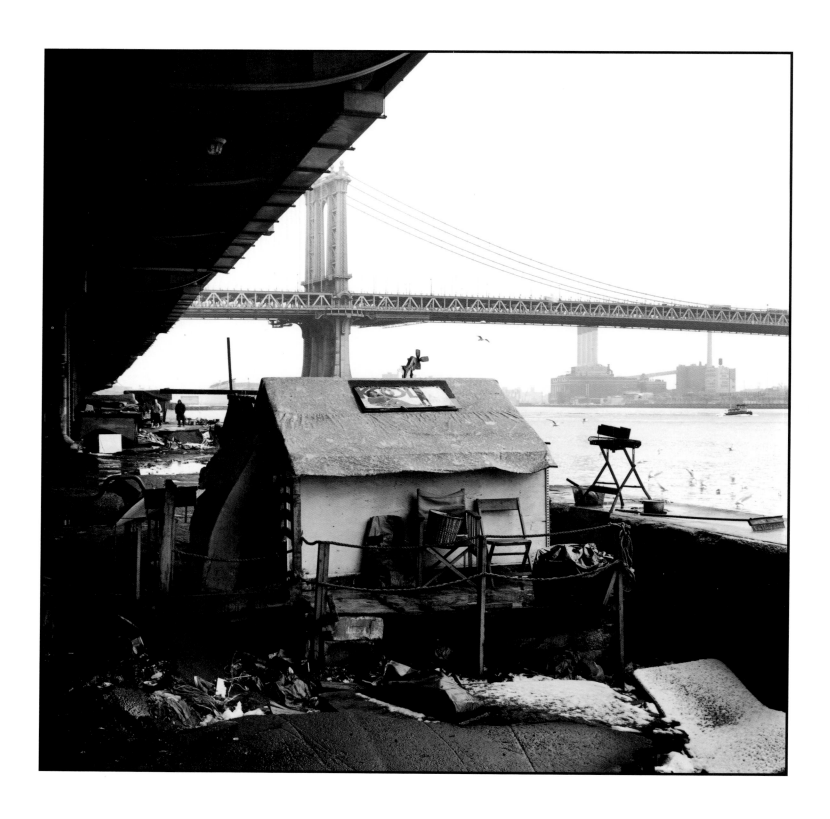

Mac's second house, East River, 1993

Christmas decorations, East River, 1994

Mizan

I first met Glenn and Mark on Trinity Street, collecting cans. They told me about this camp. I would come up here and hang out, but I wasn't ready to trust anybody, to live around anybody. I had lived in the subway but I couldn't deal with the noise of the trains. I was still dealing with my Vietnam experience and I just couldn't handle it. The river offered me the first stability I've had since 1988. I can see more clearly from here. From here you can see the mistakes that you made, you can see the things that led you to be here.

Maybe somebody runs out of food, or one of the guys is from another area where he doesn't get food. They'll come by, and if we've got food we'll give them food. This morning it was kind of cold, so I had a fire out here. Certain guys I know, they don't have a shelter. That's why all of these chairs are out here. They come by, they sit by the fire, they warm up. It's like a community.

I don't care who you are, what color you are—you come here, you're on this level, you understand that it's a matter of respect, that's all. If you can respect the fact that I'm living here, we can get along.

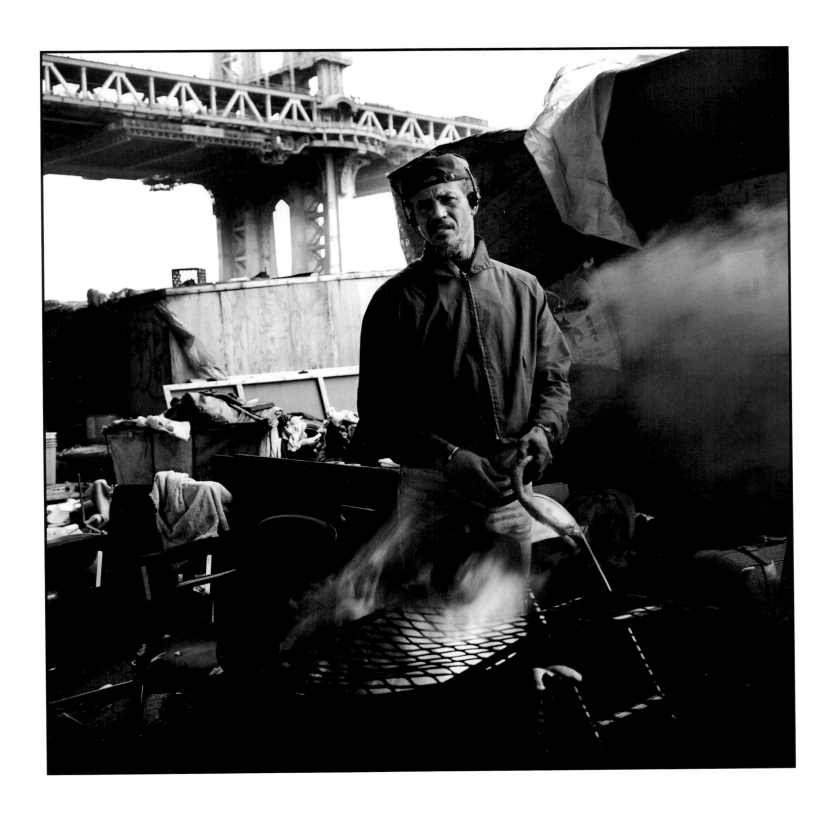

Mizan, East River, 1993

Pier 84

A massive concrete pier stretches out into the Hudson River at West Forty-fourth Street. To the south, sightseeing boats arrive and depart on the hour. To the north, tourists swarm over the *Intrepid,* a World War II aircraft carrier. The seven men on the wharf seem oblivious to these activities as they go about their work, building their homes.

Angelo's hut has two small gardens, planted with children's toys and guarded by a driftwood snake. A hand-painted wooden sign, ALDI, marks the entrance to his four-foot-high home. Angelo bends low to enter; a taller visitor must crawl on hands and knees.

The interior mysteriously seems to expand. There is a bed, a dresser, a writing desk with lamp, a basket filled with clothes, a collection of toys, framed photographs, an American flag, a handmade calendar on which Angelo marks off the days.

I've got a bad heart, high blood pressure. By the time I paid my medicine and 115 dollars a week at a hotel in Coney Island, it left me nothing to eat. A friend of mine said to come to Pier 84 and put myself a house. Little by little, I made it a little bigger, a little bigger, a little bigger.

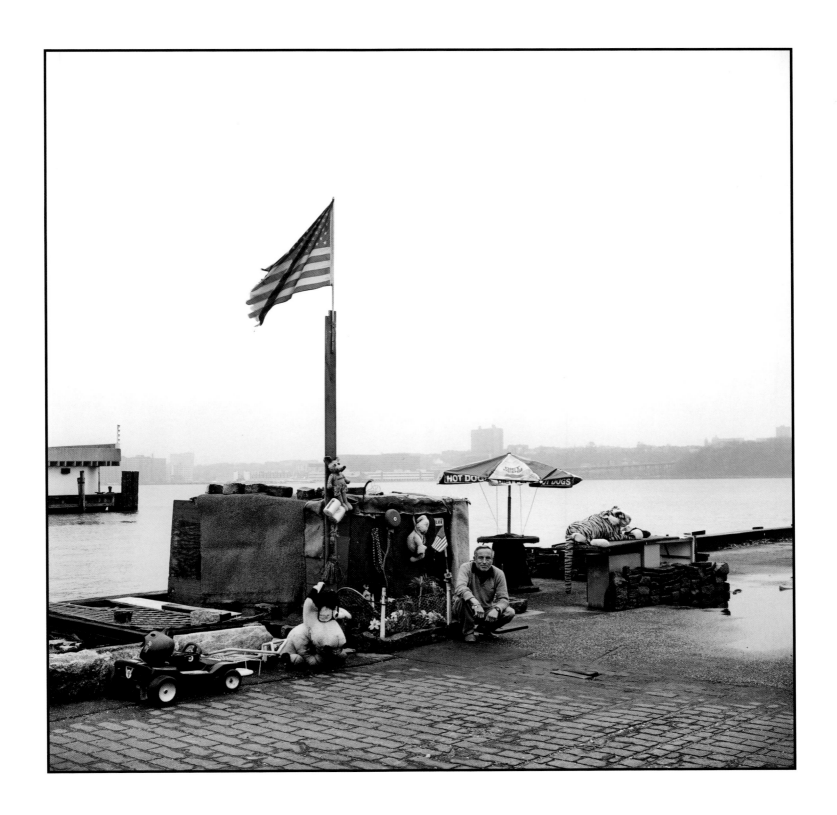

Angelo, Pier 84, 1992

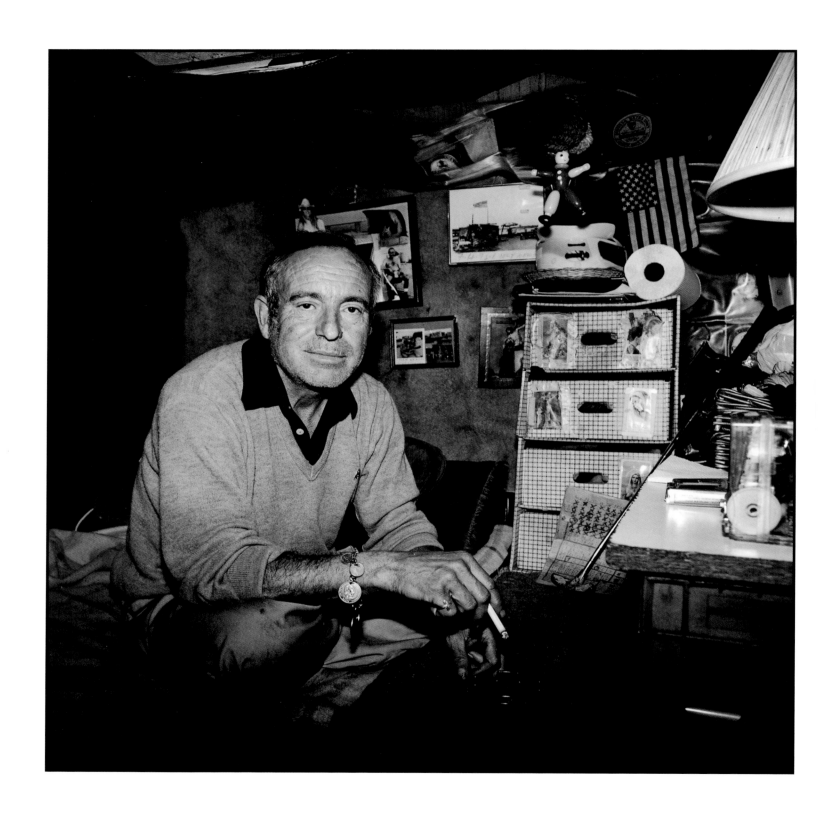

Angelo, Pier 84, 1992

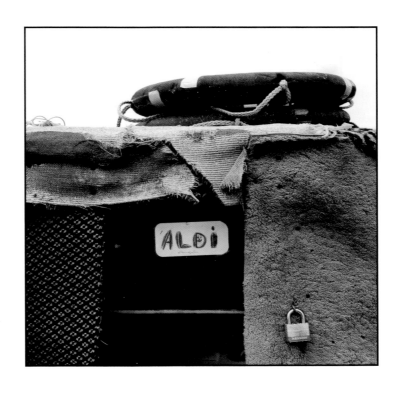

Angelo's sign, Pier 84, 1992; Angelo's garden, Pier 84, 1992

The Brooklyn Bridge

The Brooklyn Bridge begins at ground level a half-mile inland and gradually climbs to
a height of eighty-nine feet before leaving Manhattan and soaring across the East River.
The massive masonry approach houses a community of fifteen people concealed within its
cavernous interiors. Yvonne, however, tucks her mattress into an exterior niche, since her
previous place, a hollow underneath a sidewalk, was destroyed by fire. At South Street,
the bridge spans the FDR Drive and two on-ramps. High-speed traffic pounds the sloped
ceiling of Clay's home, hidden beneath the southbound ramp.

The Manhattan Bridge

Upriver at Pike Slip, near the base of the arched anchorage of the Manhattan Bridge, five
Spanish-speaking men arrange their possessions: wheeled canvas carts, a cooking grill, cartons
of canned food, and two chickens caged in a shopping cart. After bulldozers blocked their
entrance with earth and rubble, Maurice and Flaco defiantly planted a Puerto Rican flag in
the six-foot-high mound, then cut a hole in a chain-link fence to regain entry to their home.

The Seventy-ninth Street Rotunda

On the Upper West Side, traffic entering the Henry Hudson Parkway circles the rim of the
Seventy-ninth Street Rotunda. The lower level of the rotunda is a grand structure, trimmed
in granite, with a vaulted arcade that cloisters a group of homeless men in its shadows.
Larry rests behind a pile of boxes, guarded by a skull mounted on a bamboo pole, as he
reads Herman Wouk's *Don't Stop the Carnival.*

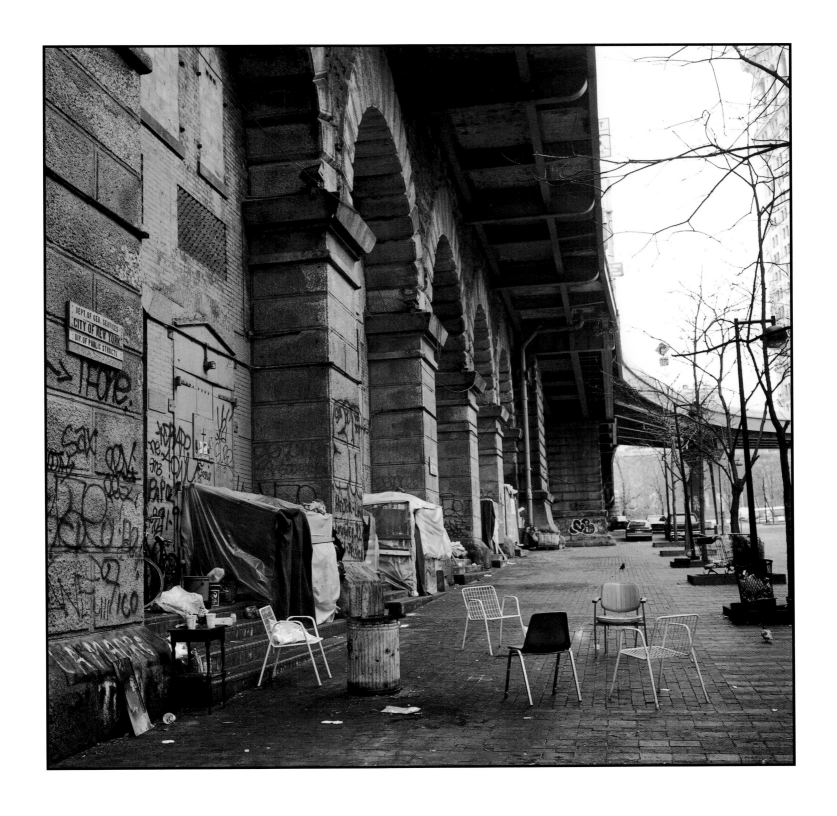

Brooklyn Bridge, 1993

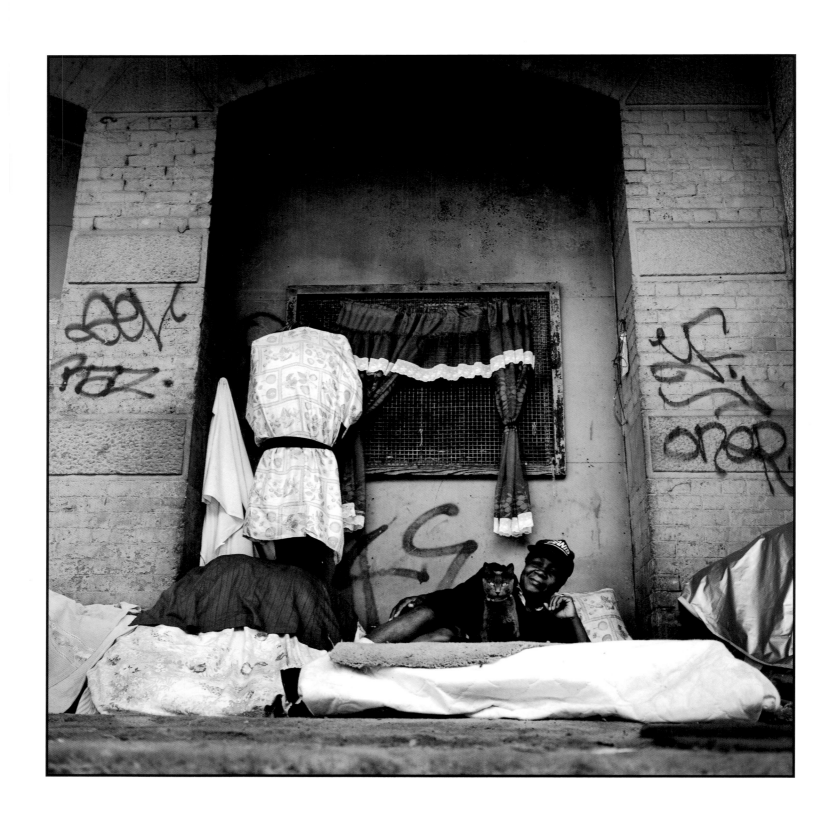

Yvonne with cat, Brooklyn Bridge, 1992

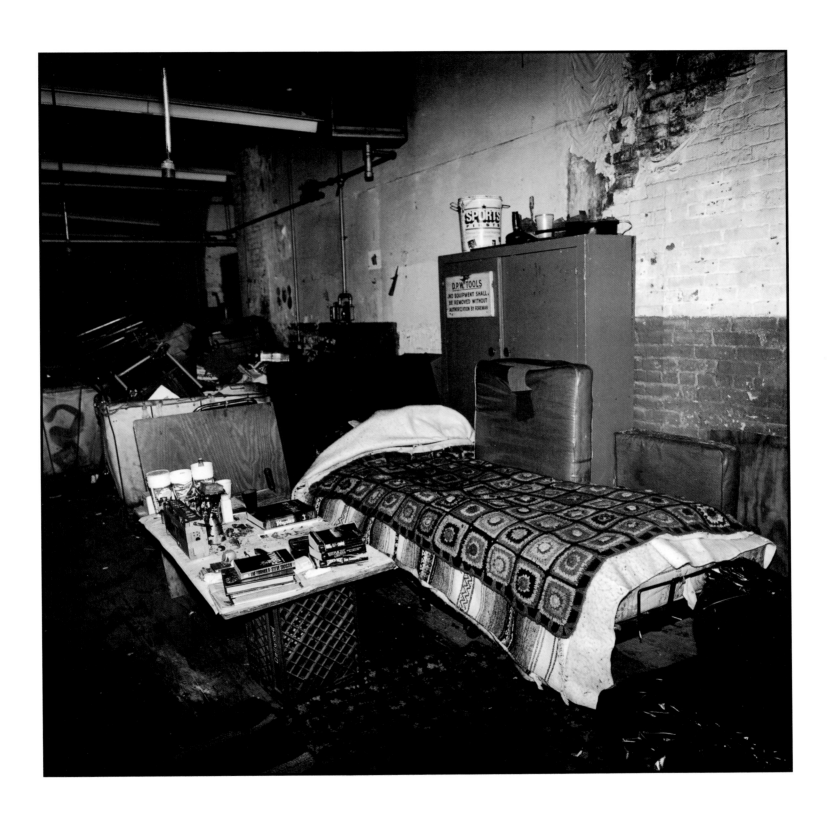

John's room, Brooklyn Bridge, 1994

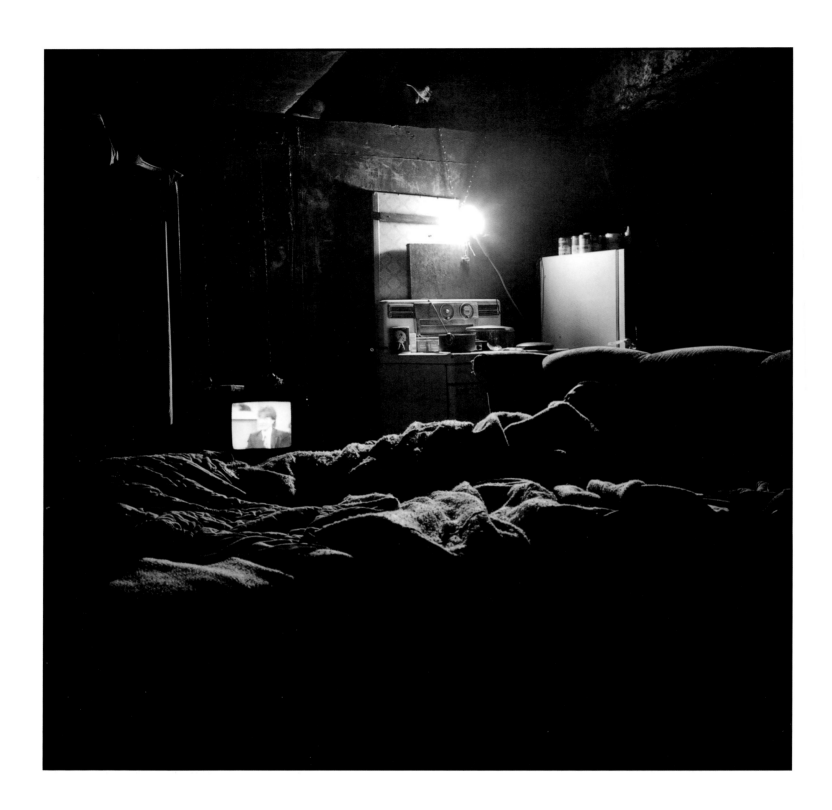

Clay, Southbound ramp, FDR Drive, 1992 98

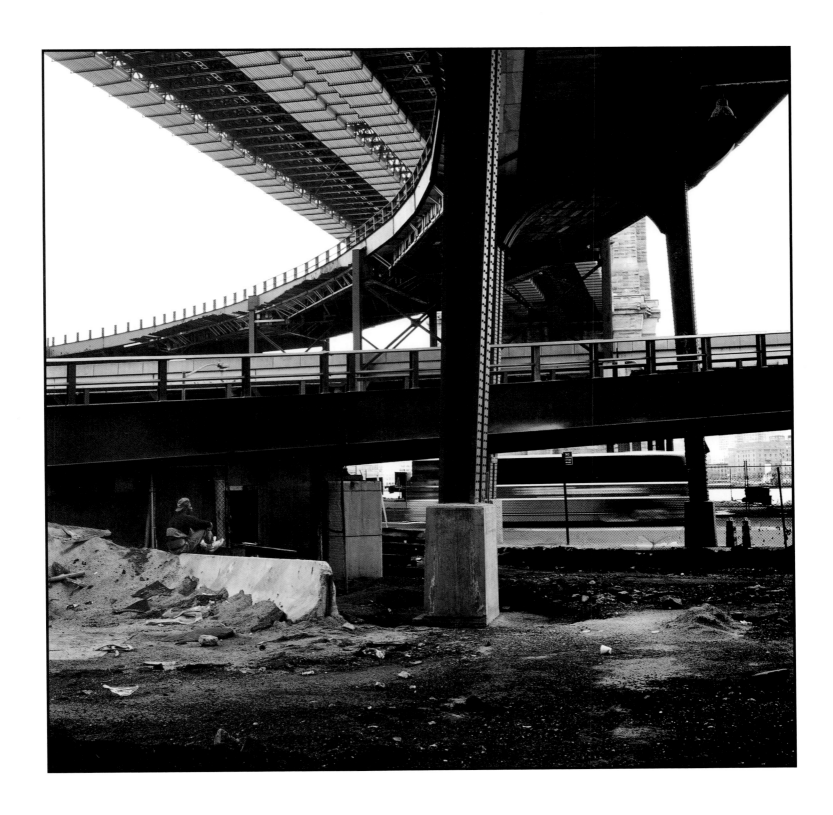

Clay, Southbound ramp, FDR Drive, 1991

Clay

Majority of the time, I think people got the wrong idea about homeless people. They think a lot of homeless people are drug addicts, bums, whatnot. You just got people that don't want to go through the system, because you go through the system, it's rough. The system don't treat people right. It's better to live out here than in one of the shelters.

I was working with the city [in Chicago]. I was a trash man and I worked for two and a half years before they laid me off. So I took off, made flight, made a new residence.

I was talking to my mom and she asked me did I have a phone. I told her, "Nah." So my mom said, "Where do you live?" I said I had a bad connection and hung up. I called her back and she ain't ask me no more. I think my brother told her.

I like doing things on my own. I learn from a lot of watching. I hooked up the electricity myself from the light pole. We found an old gas pipeline in here, too. That way I can have a decent Thanksgiving.

You'd be surprised. It's quiet. Rush hour, that's the only time you might hear some noise. Other than that, you don't hear nothing. You got your TV on in there, or you got the music playing. At night I don't hear nothing at all.

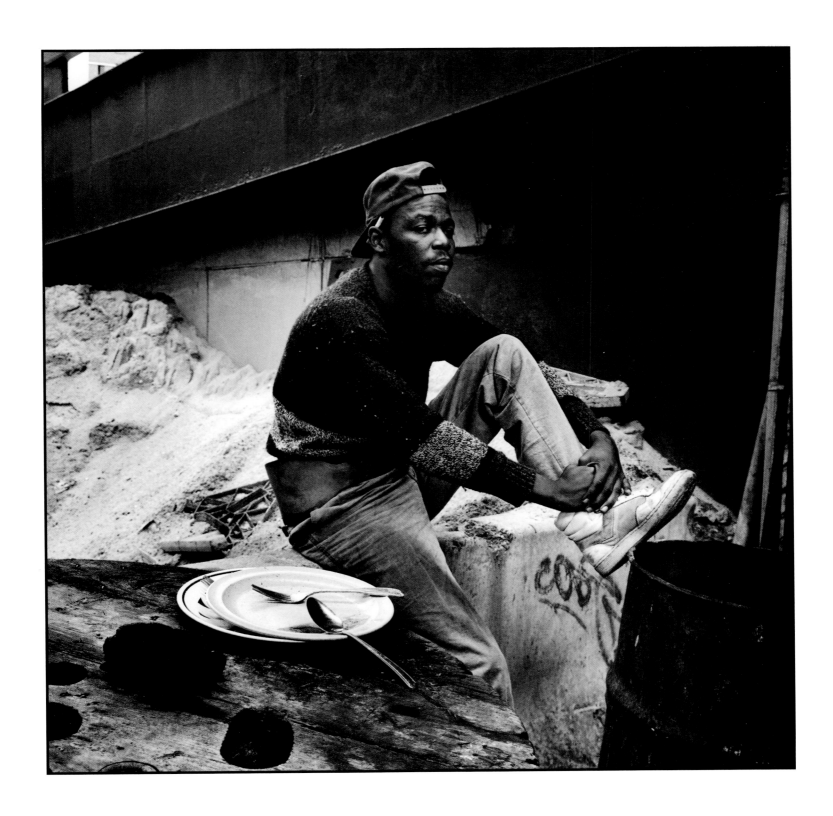

Clay, Southbound ramp, FDR Drive, 1991

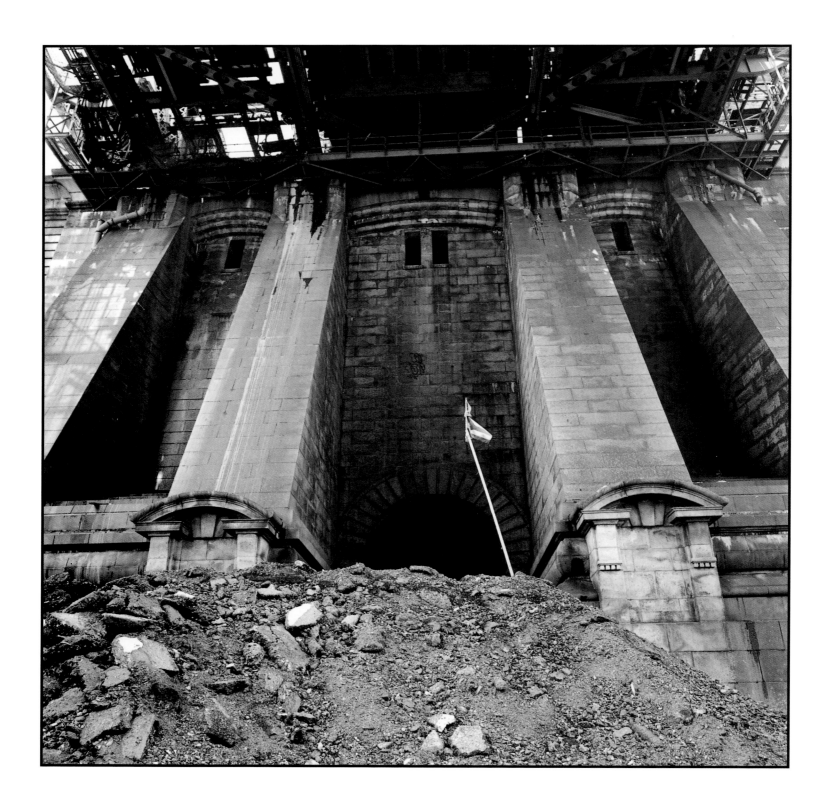

Manhattan Bridge, 1993

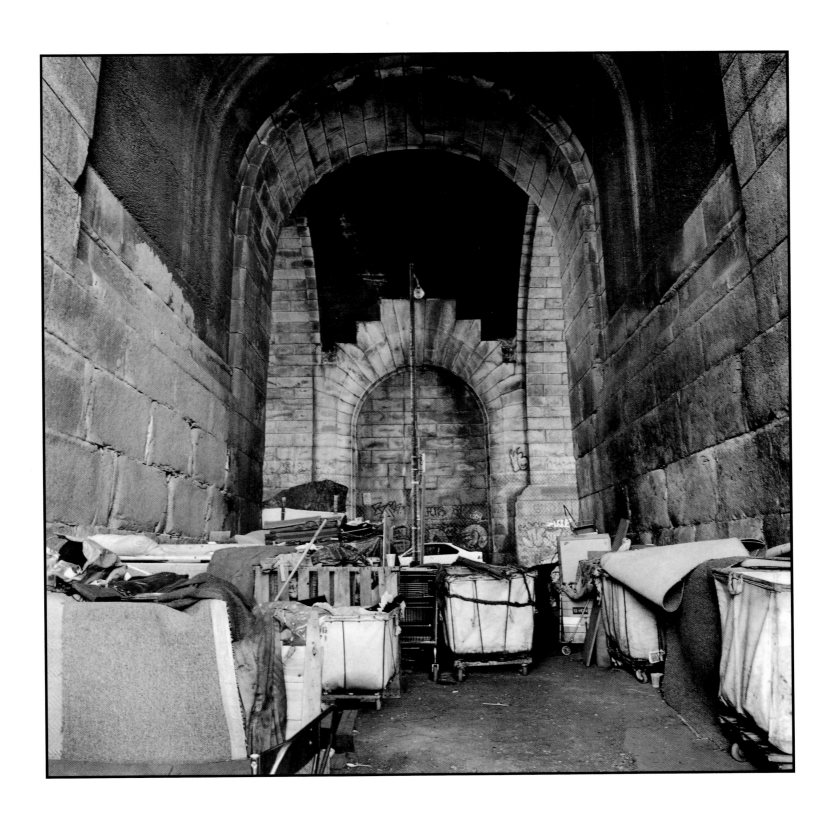

Under the Manhattan Bridge, 1993

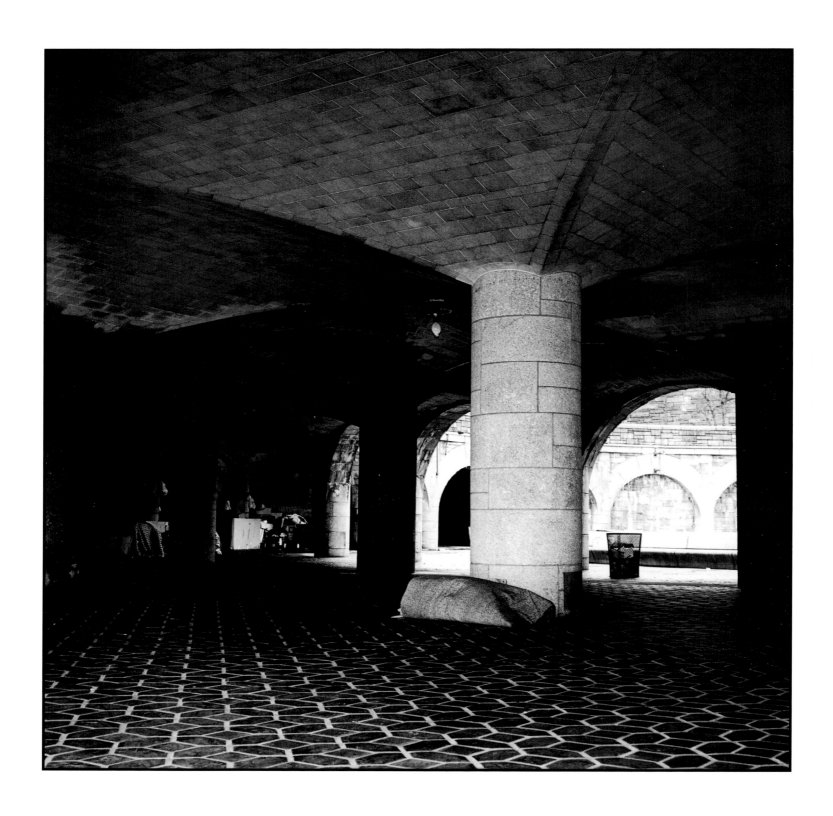

Seventy-ninth Street Rotunda, Upper West Side, 1992

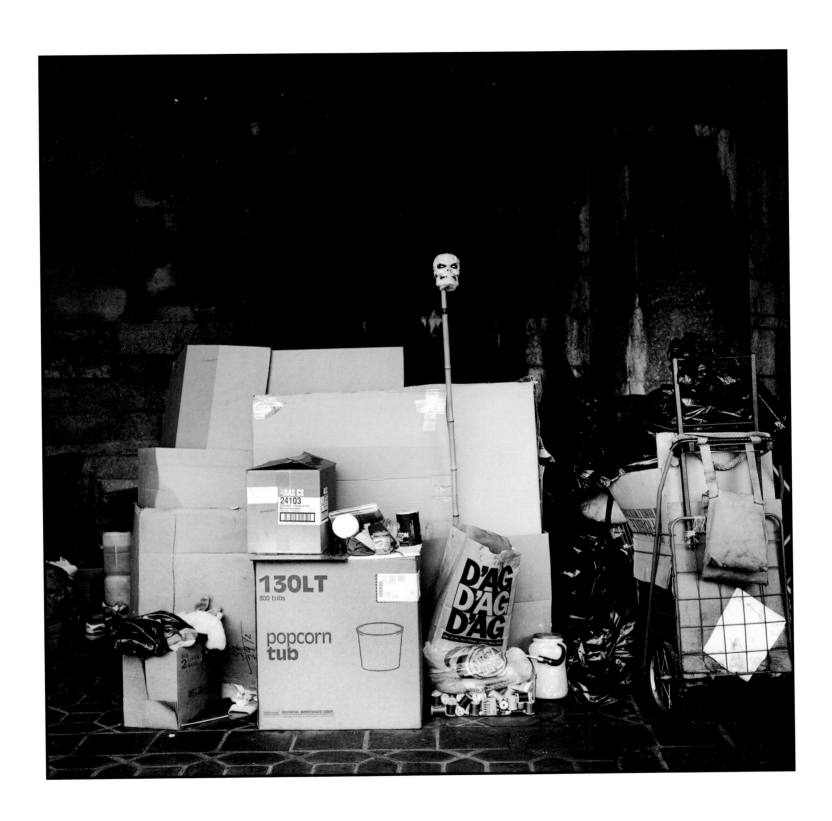

Larry's Place, Seventy-ninth Street Rotunda, Upper West Side, 1992

JR's Place

TOONEY is painted in white bubble letters on a rusting metal structure that rises forty-five feet above the Hudson River, at the end of a rotting pier. The young graffiti writer gestures toward his work, an homage to a former girlfriend. MENT, his tag, marks every surface, the signature of his perilous exploits.

A few minutes later, a man emerges from behind a sign: STAY THE FUCK OUT OF MY HOUSE. He introduces himself as JR and leads the way up a series of dizzying stairways and ladders to the chamber behind TOONEY that he calls home. There is a mattress on the floor; blankets and clothing are strewn about. Darkness falls as he tells the story of this transfer bridge, built 120 years ago to link railroad cars arriving by barge to inland tracks.

JR guides our descent with confidence, swinging down ladders and stepping boldly over gaping holes in the collapsing pier.

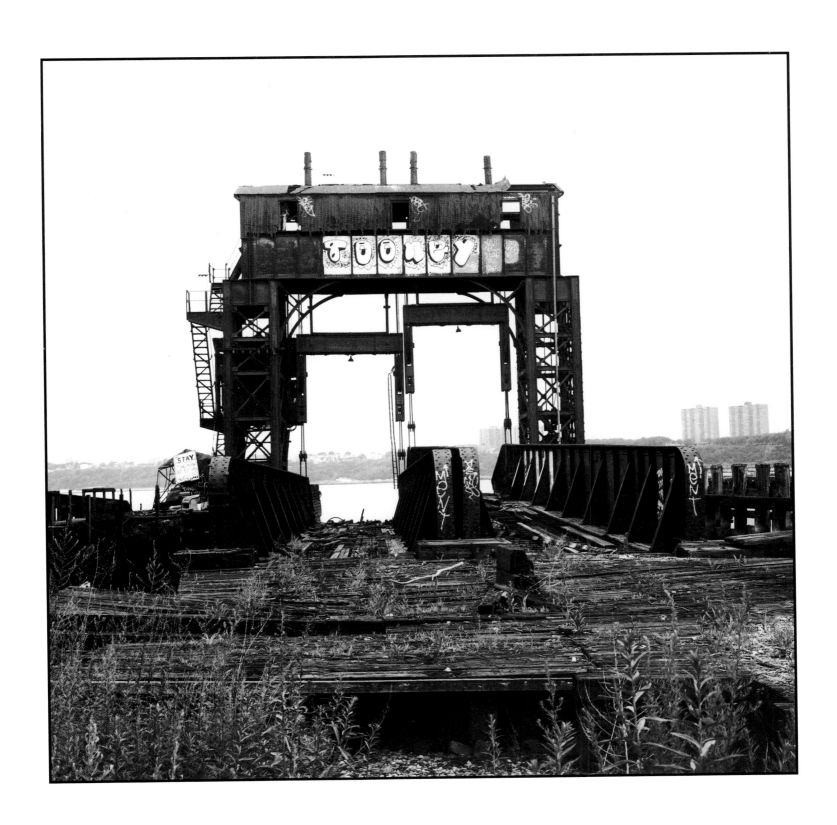

Transfer bridge, Hudson River, 1992

JR

The Bronx was home, that was the whole world. Me and my brother were robbing places from the time we were about fourteen years old. Camera stores, appliance stores, restaurants, grocery stores, it didn't matter. I got into trouble, and it was either go to jail or go into the army. I went to Vietnam when I was eighteen years old.

I got into dealing when I came back. I went to prison. After that I did about three years working as a bounty hunter in New Jersey. I came back to New York and got into more trouble, and I had to work off the books for a while. After that I spent a year in jail out on Rikers Island for assaulting a police officer. After I came out, I got a job at the Chelsea Hotel as head of security. Then, about four years ago, I got into some more trouble. I had a warrant on me, so I had to disappear. That's when I ended up here. Eventually they dropped the warrant. It's been a long forty-two years.

There's this shad fisherman out here. I was hoping maybe I could get some part-time work from him—off the books. I put my name in. He might use me if he has nobody else. I told him, "Look, anything you need—an extra hand, a little help. I ain't hard to find. Just take your boat to the dock over there." A lot of people have a stigma about people like me, but I'm honest. I got no problems telling people what I am.

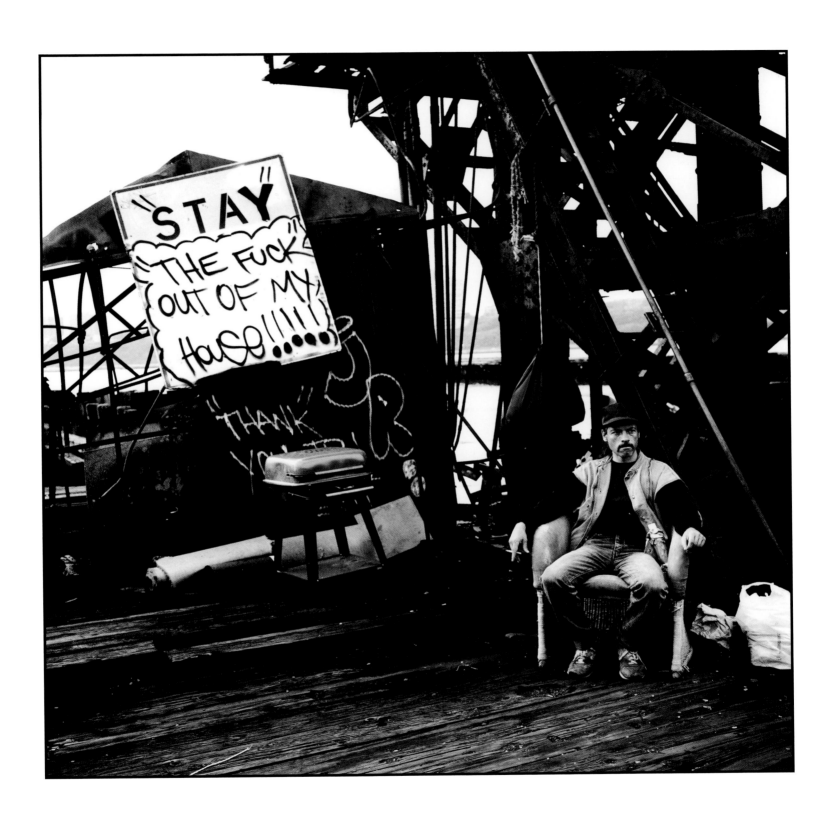

JR, transfer bridge, Hudson River, 1992

The Rail Yard

The bitter cold of January 1994 forced JR from his outpost on the transfer bridge into the narrow confines of one of twenty-seven concrete vaults that line a desolate stretch of railroad track on the Upper West Side. During the next three years, thirty-five more people found shelter in this ruin, which is all that remains of an elevated track once used by the New York Central Railroad.

Although identical in form, the concrete cubicles were gradually transformed; some people filled them with memories while others built their dreams. JR assembled a split-rail fence and hung an American flag from an ailanthus tree. Julio spanned a ditch with a long walkway made from wooden skids and enclosed a yard for his four dogs. José painted PSALM 119:113 on the wall outside his plywood door. Only Robert made no changes to his chamber, but sat at his table and wrote the first line of a poem: "You can't go back to the beginning and start anew...."

City police forced the residents to leave on February 26, 1997. Within hours, bulldozers had buried their homes with dirt and debris excavated from a construction site directly across the tracks, where a complex of luxury apartment towers was soon to rise.

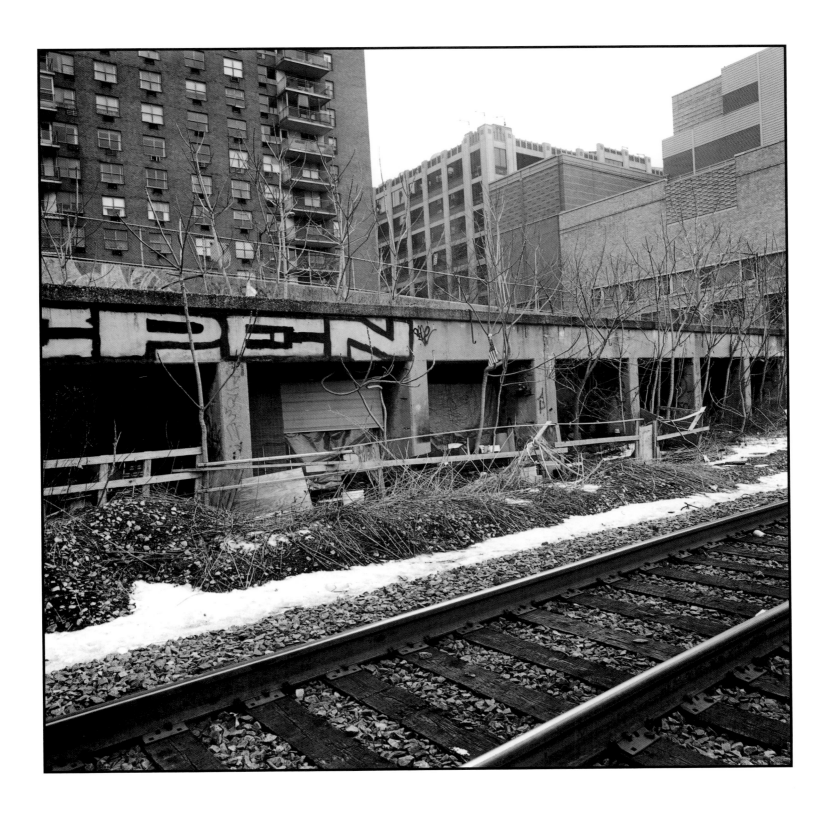

The Rail Yard, Upper West Side, 1994

Robert

José was down here first. I met him in the park. Somebody you know introduces you to another person and pretty soon you get to know a lot of people. I visited him here for three years. One day he said, "I'm out of here. I'm going back to Philadelphia." I got the place. I moved right in. There was a great big oversize bed, a table with two chairs, two windows, the door, a wood floor, an area where you could store stuff. The electricity was already connected up. Ryan and José ran wires from the light pole on street level. I have a little TV and a radio. It's nice. It's chilly, though. I can't afford an electric heater, so I have a lot of blankets. I have a lamp, but I burn candles too, because sometimes the Amtrak police will be coming around here at night. We go up to the playground at Seventy-second Street for water, or use the fire hydrant. Brian has the wrench; he opens it, for we all have friendship.

Fred and me, we eat together. We have a big old barrel, a fifty-gallon drum. We found a stove rack for on top of it, and we find wood along the streets to get the fire going. We make chicken and throw a can of vegetables in the pot—to kill the hunger. We have a hot plate and a microwave we found up on West End. They still worked. Only in Manhattan. If people move out, they just leave it. They got the money. They just don't care.

It's real nice down here. You've got Riverside Park. I pass through Lincoln Center; they've got concrete seats to sit down on, and free entertainment outside. My favorite is the jazz.

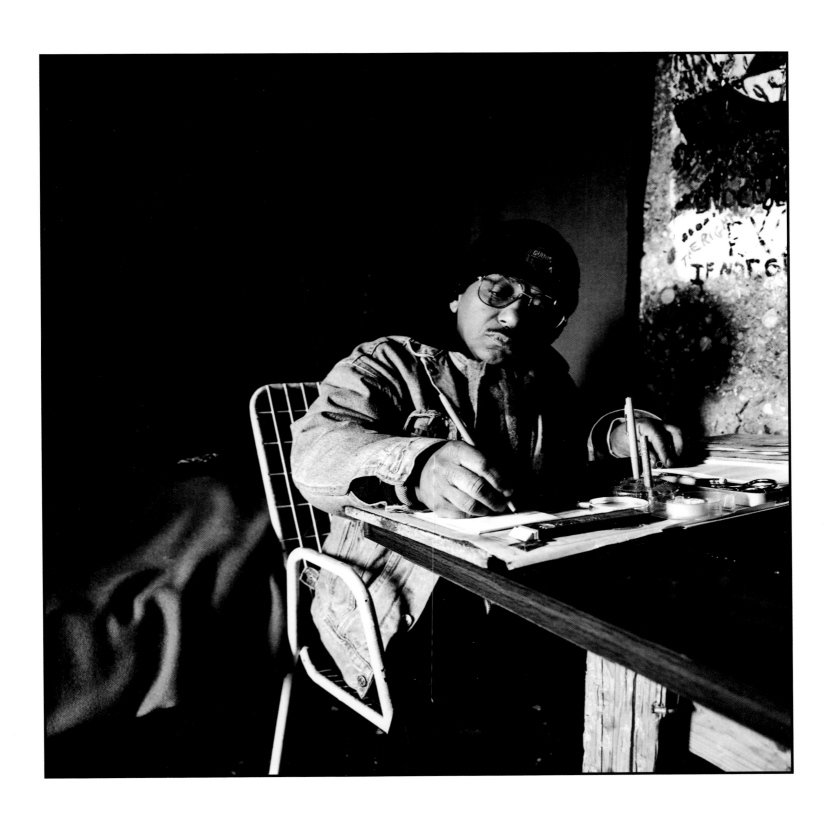

Robert, the Rail Yard, Upper West Side, 1996

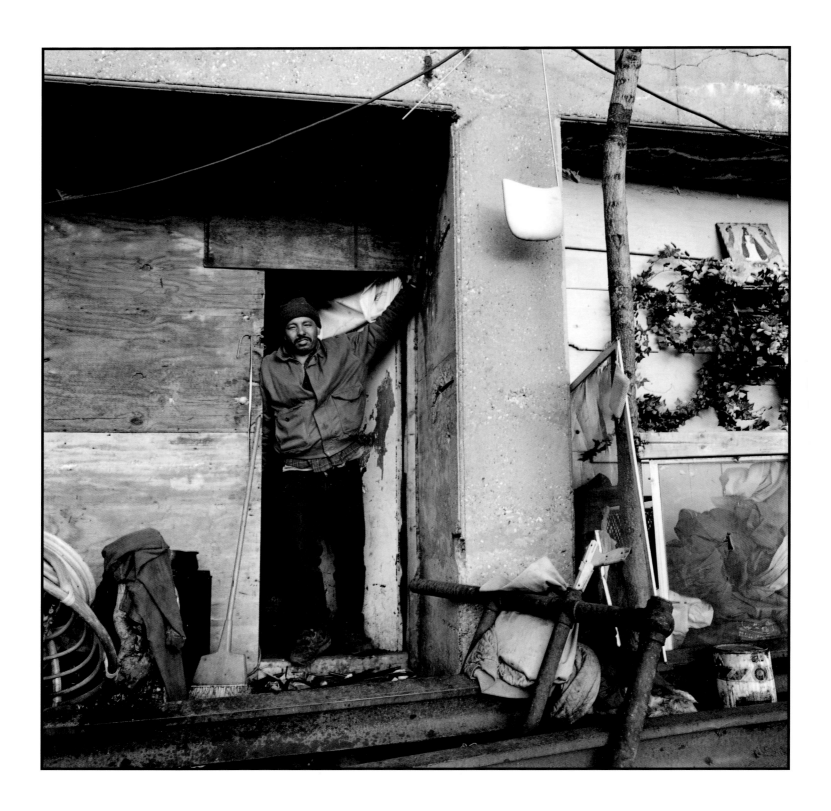

Emilio, the Rail Yard, Upper West Side, 1996

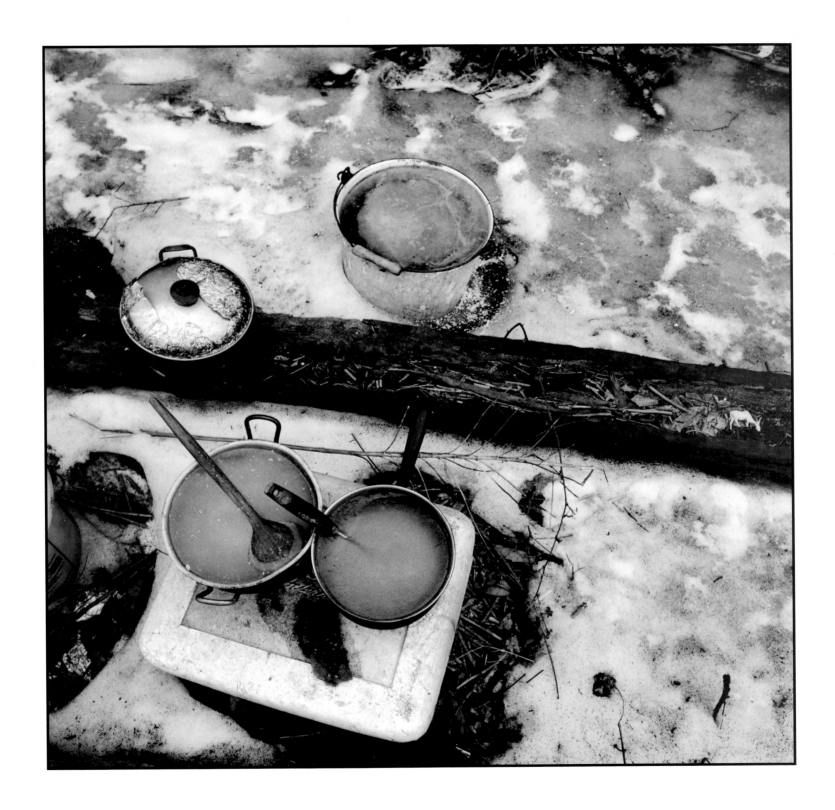

Cooking pots, the Rail Yard, Upper West Side, 1994

Emilio

I'm from Cuba. I came to Miami in 1980—the Mariel [boat lift]. They knew I never was going to be a good communist. Finally, after ten years in the USA, I said it's time to come to New York.

I used to sell clothes on the street, sell flowers, clean cars in the Bronx, delivery in Brooklyn. Finally I made enough money to buy a truck. The city gave me too many tickets—for nothing, for everything. I sometimes made three or four hundred dollars and had to pay two hundred dollars on the ticket, plus gas, the mechanic, insurance, parking—everything. I decided no more, and sold my van.

I came here about one year ago. I try to work all the time. I do anything. Then I buy some food, sometimes cigarettes, that's it. I don't have to pay rent over here. I don't have expenses. I can get clothes anywhere. I go to the movies, sometimes I watch the television.

I feel frustrated sometimes when I do nothing, because there are so many things I can do. Sometimes, the way I'm dressed now, people look at me and say, "This is the homeless, this is a bum," and they don't want to give me a job. When I live in my own place, where I can take a shower, I know I can work it.

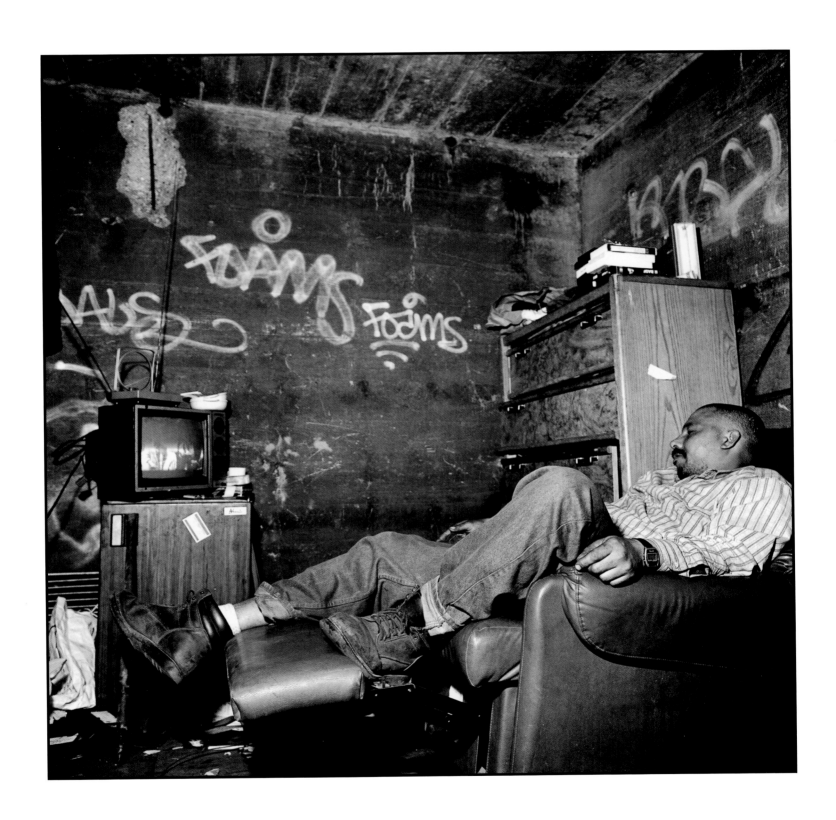

Emilio, the Rail Yard, Upper West Side, 1995

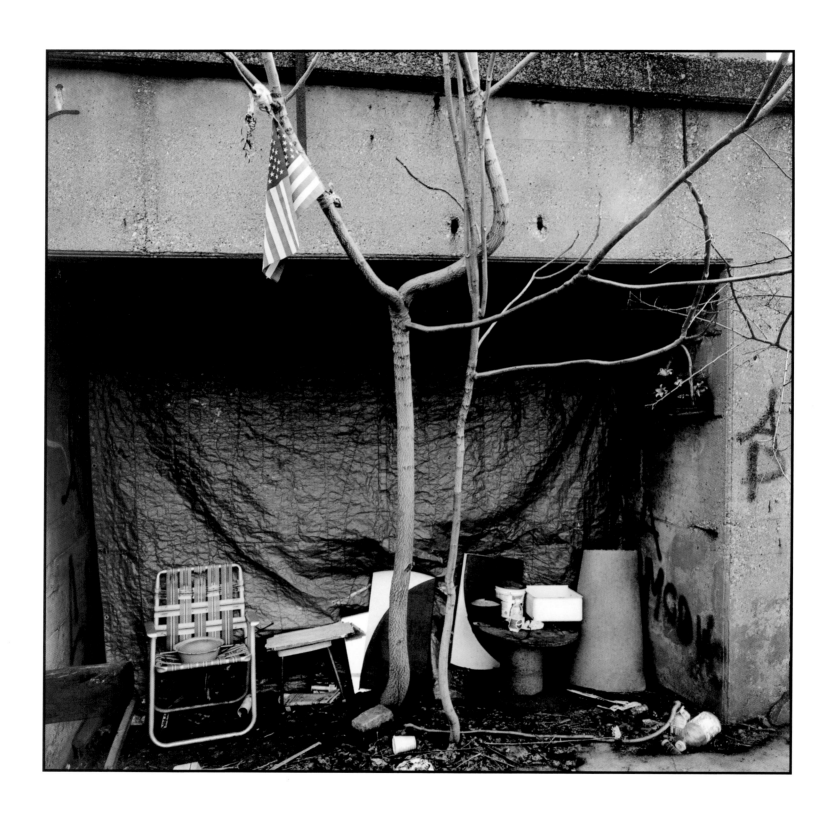

Entrance to JR's place, the Rail Yard, Upper West Side, 1994

The Rail Yard, Upper West Side, 1996

When city police razed the Rail Yard encampment on February 26, 1997, they demolished the last shantytown in Manhattan. Since then, the numbers of homeless poor have not diminished, but they have become less visible. Fearful of police, the dispossessed journey the streets alone, urban nomads forever on the move: riding subways throughout the night; sleeping on dark, silent streets; hiding in the shadows of construction sites; tucking themselves into decaying structures along the waterfront; disappearing before dawn.

The Crisis of Homelessness

Patrick Markee, Senior Policy Analyst, Coalition for the Homeless

The 1997 demolition of the Upper West Side Rail Yard encampment served as a vivid reminder that New York City had become, in the 1990s, an even colder and meaner place for homeless people. Mayor Rudolph Giuliani's decision to reorient the city's police department away from community policing towards zero-tolerance enforcement of so-called quality of life offenses had a devastating impact on streetbound homeless New Yorkers. In 1996 the police department issued a "Quality of Life Enforcement Guide," instructing its officers to arrest or issue summonses to panhandlers and people sleeping in parks or on sidewalks. At the same time, the police began working alongside homeless-outreach teams to catalog encampments and shantytowns, and to conduct periodic "sweeps" of homeless people. The city's courthouses grew crowded with homeless people answering summonses, as well as those arrested for minor violations.

In short, the tacit agreement that had emerged in the previous decade between New York City residents and their homeless neighbors began to break down in the 1990s. This was particularly tragic since the decade had begun with an enormously successful effort to address the problem of homelessness. In 1990 Mayor David Dinkins and Governor Mario Cuomo had signed the New York/New York Agreement, a city-state commitment to produce nearly five thousand units of housing with on-site services for homeless people living with mental illness. Along with similar efforts to provide supportive housing for homeless people living with AIDS, this agreement led to the first substantial reductions in New York City's homeless population since mass homelessness emerged in the late 1970s. Indeed, by 1994 the adult shelter population had fallen by nearly 40 percent, and the number of homeless people on city streets had declined dramatically.

"What happened to all the homeless people?" became a commonplace question in New York City in the mid-1990s. One answer was, "Thousands moved into New York/New York apartments and other supportive housing." However, the story took another tragic turn

shortly thereafter. In the late 1990s, Mayor Giuliani and Governor George Pataki let the New York/New York Agreement expire, and the shelter population began to rise again. Homeless-outreach teams reported that more homeless people—in particular individuals with mental illness—were bedding down on city streets.

But, unlike the sharp rise we witnessed in the 1980s, this time the situation on the streets was far meaner. Homeless people were no longer allowed to gather in groups or in encampments, or to sleep in the same spot for more than a few nights. The street homeless became more nomadic, furtively avoiding the police and other authority figures. Many chose to sleep on subway trains or farther away from Manhattan neighborhoods where tourists or the wealthy congregated, and where police enforcement was most intensive. Homeless New Yorkers, once the most visible sign of the failures of housing policies and the mental health system, were pushed to the city's margins.

The recent spike in homelessness, both in New York City and nationwide, has occurred despite unprecedented economic growth. Never before has government had at its disposal such enormous resources to invest in supportive housing and other proven solutions. The problem of homelessness remains eminently solvable; all that is lacking is the will of our elected officials. As mass homelessness enters its third decade, our society must ensure that every American has a decent, affordable home, and that no one is relegated to cold city streets.

Epilogue

Bushville was demolished on December 15, 1993. Pepe was the only resident to be offered subsidized housing. He died on January 7, 1997, at age seventy. Papito, a visitor who lived in a nearby apartment, died two years ago. Mario slept on the sidewalk, around the corner from Bushville, until his death in 1998 at age sixty. Hector relocated to the basement of a nearby apartment building. Hector A joined his two sons in their late mother's apartment less than a block from Bushville. Juan died at Bushville on November 11, 1991. Tanya and Duke lived for seven months in a stripped van, up on blocks in a vacant lot on East Ninth Street, before moving into an abandoned building in the neighborhood. Gumercindo, a visitor, still lives in the same Lower East Side apartment. Figueroa, a visitor who lived in an apartment, moved away from the neighborhood.

Jimmy's camp was razed by a private developer within a week of my July 3, 1991, visit. Jimmy was never seen in the area again. The Eighth Street encampments were bulldozed by the city on October 15, 1991. Rasta relocated to a less conspicuous vacant lot nearby. Deanna has moved from the neighborhood. Rice stayed with his family for a year, then moved into subsidized housing in the Bronx. He still seeks employment. Terry died of AIDS on December 12, 1993. He was thirty-six years old and living in an apartment in Brooklyn. Reni moved into an abandoned building on the Lower East Side. Moses's whereabouts are unknown. James slept in city shelters for five years before moving into subsidized housing on the Upper West Side. He has a full-time job with a delivery company.

The Hill was demolished on August 17, 1993. Louie relocated to the East River encampment, but never built a hut for himself. He drowned in the river on May 18, 1995, at age fifty-four. Sam Wong slept on the streets of Chinatown for several years. The whereabouts of Barbara and Ace are unknown. Mr. Lee died at the Hill on May 29, 1992, at age sixty-one. The man charged with Mr. Lee's murder pleaded guilty in 1996 and remains in prison.

The East River encampment was demolished on July 1, 1996. Mac moved to another location in the neighborhood and continued to collect and sell scrap metal to earn money. Mark was murdered, his body found at the bottom of a recycling cart on June 4, 1994. He was interred at the potter's field, on Hart Island; Mark was forty years old. Slim relocated to a friend's apartment in the neighborhood. BK's whereabouts are unknown. Hettie moved from the neighborhood. Maurice moved to another location in the neighborhood and continued to collect beverage cans to redeem for cash at recycling centers. Mizan lives in an apartment in Harlem. He volunteers as a computer instructor at the Veteran's Administration Library and is writing about his experiences as a platoon sergeant in Vietnam. C, Doug's brother, left the East River encampment in 1993. He died in 1995 at age forty-five. Doug left in 1994. He slept at a shelter for three months, then lived with a friend for a year while working at a temporary employment agency. He has worked full-time for five years and rents an apartment in Queens. Jimmy's whereabouts are unknown. Marian still lives in the area and earns money redeeming recyclable cans. Since his departure from Pier 84, Angelo's whereabouts are unknown.

The Brooklyn Bridge residents were evicted on April 14, 1994. The Manhattan Bridge and Seventy-ninth Street Rotunda encampments have been routed periodically. Yvonne's whereabouts are unknown. Clay lives with a friend in the neighborhood and continues to collect beverage cans, which he redeems for cash at a recycling center.

JR's whereabouts are unknown. MENT (Brian), who painted TOONEY in 1992, lived in a railroad tunnel for four years before relocating to Spanish Harlem. The Rail Yard encampment was demolished by the city on February 26, 1997. Robert lives in subsidized housing in the Bronx, where he continues to write poetry. Julio, who built the most elaborate home in the Rail Yard, lives in an abandoned car on the West Side. Emilio lives in a subsidized apartment in Spanish Harlem. He works on construction projects to earn money and composes salsa, merengue, and bolero music for his own enjoyment.

Surnames have been omitted out of respect for individual requests for anonymity.

Notes on *Fragile Dwelling*

Background information for the prologue was culled from:
Nels Anderson's "The Homeless in New York City," a 1934 report for the Welfare Council of New York; *On Being Homeless: Historical Perspectives* (New York: Museum of the City of New York, 1987), edited by Rick Beard; Kim Hopper's "A Poor Apart: The Distancing of Homeless Men in New York City's History," *Social Research*, vol. 58, no. 1, Spring 1991, and "Public Shelter as 'a Hybrid Institution': Homeless Men in Historical Perspective," *Journal of Social Issues*, vol. 46, no. 4, 1990; *From Urban Village to East Village*, by Janet L. Abu-Lughod et al. (Cambridge: Blackwell, 1994); back issues of *The New York Times;* and my own documentation of the homeless communities in Tompkins Square Park from 1989 to 1991, and throughout Manhattan from 1991 to the present. Patrick Markee, senior policy analyst at Coalition for the Homeless, provided background data and a careful reading of the text, as did Kim Hopper, senior research fellow at the Nathan S. Kline Psychiatric Institute. Fred Siegel, senior fellow at the Progressive Policy Institute, contributed background information on the 1975 fiscal crisis.

In addition to my own observation and documentation, background information on the sites was culled from: David McCullough's *The Great Bridge: The Epic Story of the Building of the Brooklyn Bridge* (New York: Simon and Schuster, 1972); Alan Trachtenberg's *Brooklyn Bridge: Fact and Symbol* (New York: Oxford, 1965); Carl W. Condit's *The Port of New York* (Chicago: University of Chicago Press, 1980); Robert Caro's *The Power Broker* (New York: Knopf, 1974); and Thomas R. Flagg's "The Transfer Bridge at the Port of New York," in *Transfer* no. 12, 1994; and articles in *The New York Times*. Additional information was provided by Coalition for the Homeless; Richard Rubel, community relations officer for Amtrak; and Clark Hampe, director of operations planning for Amtrak. Further information on artists Gabriele and Nick Manhattan's tepee project at the Hill can be found at www.users.interport.net/~thieves. My documentation of the homeless communities of Manhattan began in 1989 in Tompkins Square Park, under the title *The Architecture of Despair*. I began to photograph *Fragile Dwelling* in 1991, making several visits a week to Bushville, the Eighth Street Lots, the Hill, and the East River until the encampments were destroyed. Over the course of six years, I paid less-frequent visits to the other communities. My documentation included as well the demolition of the encampments in Tompkins Square Park, Bushville, the Eighth Street lots, the Hill, the 1994 bulldozing of seven East River huts, and the eviction of the Brooklyn Bridge community. The oral histories in *Fragile Dwelling* were edited from audiotaped interviews I collected between 1991 and 2000. Additional interviews between 1998 and 2000 were transcribed from notes. The photographs were made with a Mamiya 6, a medium-format rangefinder camera. Information about the project is available at www.fragiledwelling.org.

Additional readings suggested by Coalition for the Homeless:
Baumohl, Jim, ed. *Homelessness in America*. Phoenix, AZ: Oryx Press, 1996.
Coalition for the Homeless, *"What Is Government For?": The Surge of Homeless Persons with Mental Illness in New York City*. New York: Coalition for the Homeless, 1993.
Coalition for the Homeless, *Legacy of Neglect: The Impact of Welfare Reform on New York's Homeless*. New York: Coalition for the Homeless, August 1999.
Dehavenon, Anna Lou. *Charles Dickens Meets Franz Kafka in 1997: How the Giuliani Administration Flouted Court Orders and Abused Homeless Families and Children*. Action Research Project on Hunger, Homelessness and Family Health, November 1998.
Jiler, John. *Sleeping with the Mayor: A True Story*. St. Paul, MN: Hungry Mind Press, 1997.
O'Flaherty, Brendan. *Making Room: The Economics of Homelessness*. Cambridge: Harvard University Press, 1996.
Orwell, George. *Down and Out in Paris and London*. New York City: Perma, 1953.
Schill, Michael H., ed. *Housing and Community Development in New York City: Facing the Future*. Albany: SUNY Press, 1999.
Sendak, Maurice. *We Are All in the Dumps with Jack and Guy*. New York City: Harper Collins, 1993.
Shinn, Marybeth, and S. Tsemberis. "Is housing the cure for homelessness?" In *Addressing Community Problems: Research and Intervention*, edited by X.B. Arriaga and S. Oskamp, 52-77. Thousand Oaks, CA: Sage, 1998.
Stringer, Lee. *Grand Central Winter: Stories from the Street*. New York City: Washington Square Press, 1998.

Acknowledgments

The individuals who lived in these communities graciously invited me into their homes and generously offered me hours of their time. I am deeply grateful for their friendship and trust.

Although I photographed alone, this project could not have been realized without the support of institutions and the advice and encouragement of colleagues, family, and friends. Financial assistance arrived at moments when it would have been impossible to continue without it. The New York State Council on the Arts initially funded the project through an Individual Artist Grant in Architecture, Design, and Planning. The project was later sustained by a Visual Artist Fellowship in Photography from the National Endowment for the Arts, and by a grant from the Graham Foundation for Advanced Studies in the Fine Arts.

The Cooper Union for the Advancement of Science and Art provided immeasurable support for this ten-year project. Jay Iselin and Beverly Wilson encouraged me to organize a symposium on homeless issues in 1992, which considerably broadened my perspective. Robert Hawks generously offered sound advice and solutions. Robert Rindler graciously provided support to the sometimes overwhelming combination of full-time teaching responsibilities and artistic pursuits, and encouraged me to write about the East River encampment for the School of Art's 1998 exhibition, New York Photographs. A two-semester sabbatical gave me the time and assistance I needed to complete this book. Colleagues Philippe Apeloig, Georgette Ballance, and Norman Sanders shared typographic and technical expertise, as did Mindy Lang and her staff at the Cooper Union Center for Design and Typography, who also shared their facilities. Kirsten Munro polished numerous grant proposals. Ann Holcomb aided with essential research. Cooper Union student Christine Beardsell cheerfully and tirelessly assisted me for four years, and computer-formatted my initial design for Fragile Dwelling. Interns Zeva Bellel, Lucy Leirião, Tiffani Casteel Replogle, and Brent Schumann helped me at different stages.

Kathy Kennedy made the gelatin silver prints for this book and has provided support for the project for more than ten years. Kai Erikson and Steve Zeitlin encouraged me to collect the oral histories, and Jacklynn Johnson transcribed most of the audiotapes.

I owe a very special debt to Gloria Kury, who was unfailingly generous with her considerable learning, critical insight, and unflagging enthusiasm throughout the entire project. Her careful and deep reading taught me much, and the manuscript benefited enormously from her discerning responses. Barbara Spackman and Brian Drolet patiently read the manuscript at many stages, and their provocative commentary also shaped the text. Barbara Epler's editorial expertise and sensitive reading were an invaluable contribution. Maria Luisa Ardizzone, Diana Balmori, and Nathaniel Foote provided input at crucial stages. Patrick Markee read and reread the prologue; Kim Hopper and Fred Siegel generously made suggestions on its early drafts.

Richard Rubel and Clark Hampe shared important background information on the Rail Yard, and Thomas R. Flagg contributed his remarkable research. Nellie Gonzalez-Liebeskind patiently provided the cultural background and Spanish translations for the Bushville section. William Butler, Stanley Greenberg, and Steve Tsou kindly answered my queries on infrastructure and architecture.

I am truly grateful to the Aperture Foundation for its commitment to publishing Fragile Dwelling. Peggy Roalf, the editor, introduced my work to Michael Hoffman through the Aperture issue Shared Lives: The Communal Spirit Today, and ardently championed the publication of this book. Stevan A. Baron skillfully supervised production. Dawn Rogala designed the cover and formatted the pages with sensitivity. Hiuwai Chu and Lesley Martin enthusiastically provided editorial assistance. Alex Zucker carefully copyedited the manuscript.

Julia VanHaaften supported this project through the acquisition of photographs for the New York Public Library Department of Prints and Photographs. The Museum of the City of New York, the National Building Museum in Washington, DC, and the Boston Architectural Center, as well as numerous others, made it possible for this

project to reach a wider audience through exhibitions and publications. The Margaret Bodell Gallery, Claudia Hirtl, John Hill, Conrad Levenson, Kim Sichel, Maren Stange, Claudia Steinberg, Alan Trachtenberg, and Bonnie Yochelson all actively supported the project on numerous occasions. Roy Kaufman, Yolanda Knull, E.J. Monteith-Koster, and Sigrid Rothe frequently offered sound advice. Virl Andrick, Beverly Feher, Jilleen Johnson, Pearl Jones, Barbara Marken, Lloyd Miller, Janet Odgis, Judith Orsine, and Marc Singer, along with many other friends and family members offered support at crucial moments. Gabriele and Nick Manhattan shared their fire at the Hill, and continue to share their friendship.

I will always be grateful to my mother. Fond memories of her love and encouragement were with me as I completed this book.

When people in these homeless communities were in desperate need, Mary Brosnahan and her staff at the Coalition for the Homeless were always there to provide compassion, hope, and solutions. Mizan, who lived along the East River, spoke about the Coalition's vital contribution to the encampment's morale and sustenance: *The Coalition was a lifeline. When their food van stopped in front of our hut, the brakes would squeak a little bit. We knew the sound. It was like a song, a melody.*

Fragile Dwelling was supported in part by
Coalition for the Homeless
and
The Cooper Union for the Advancement of Science and Art

Library of Congress Catalog Card Number: 00-104315
Hardcover ISBN: 0-89381-915-8
Jacket design and typography by Dawn Rogala
Separations by Articrom s.r.l., Velate, Italy
Printed and bound by Musumeci Printing, Aosta, Italy

The Staff at Aperture for *Fragile Dwelling*:
Michael E. Hoffman, Executive Director
Michael L. Sand, Executive Editor
Peggy Roalf, Editor; Hiuwai Chu, Assistant Editor
Stevan A. Baron, V.P., Production; Lisa A. Farmer, Production Director
Olga Gourko, Design Work-Scholar; Paige McCurdy, Production Work-Scholar

Aperture Foundation publishes a periodical, books, and portfolios of fine photography and presents world-class
exhibitions to communicate with serious photographers and creative people everywhere. A complete catalog
is available upon request. Aperture Customer Service: 20 East 23rd Street, New York, New York 10010.
Phone: (212) 598-4205. Fax: (212) 598-4015. Toll-free: (800) 929-2323. E-mail: customerservice@aperture.org
Aperture Foundation, including Book Center and Burden Gallery: 20 East 23rd Street, New York, New York
10010. Phone: (212) 505-5555, ext. 300. Fax: (212) 979-7759. E-mail: info@aperture.org

Visit Aperture's website: www.aperture.org

Aperture Foundation books are distributed internationally through:
CANADA: General/Irwin Publishing Co., Ltd., 325 Humber College Blvd., Etobicoke, Ontario, M9W 7C3.
Fax: (416) 213-1917.
UNITED KINGDOM, SCANDINAVIA, AND CONTINENTAL EUROPE: Robert Hale, Ltd., Clerkenwell House,
45-47 Clerkenwell Green, London, United Kingdom, EC1R OHT. Fax: (44) 171-490-4958.
NETHERLANDS, BELGIUM, LUXEMBURG: Nilsson & Lamm, BV, Pampuslaan 212-214, P.O. Box 195,
1382 JS Weesp, Netherlands. Fax: (31) 29-441-5054.
AUSTRALIA: Tower Books Pty. Ltd., Unit 9/19 Rodborough Road, Frenchs Forest, Sydney, New South Wales,
Australia. Fax: (61) 2-9975-5599.
NEW ZEALAND: Southern Publishers Group, 22 Burleigh Street, Grafton, Auckland, New Zealand.
Fax: (64) 9-309-6170.
INDIA: TBI Publishers, 46, Housing Project, South Extension Part-I, New Delhi 110049, India.
Fax: (91) 11-461-0576.

For international magazine subscription orders to the periodical *Aperture*, contact Aperture International
Subscription Service, P.O. Box 14, Harold Hill, Romford, RM3 8EQ, United Kingdom. One year: $50.00. Price
subject to change. Fax: (44) 1-708-372-046. To subscribe to the periodical *Aperture* in the U.S.A. write Aperture,
P.O. Box 3000, Denville, New Jersey 07834. Toll-free: (800) 783-4903. One year: $40.00. Two years: $66.00.

First Edition
10 9 8 7 6 5 4 3 2 1

A portion of the proceeds from the sale of Fragile Dwelling *will go to Coalition for the Homeless.*